Plan & Go | Hiking Photography

All you need to know to take better pictures on every trail

Alison Newberry, Matt Sparapani

sandiburg press

Plan & Go | Hiking Photography

All you need to know to take better pictures on every trail

Copyright © 2017 by Alison Newberry, Matt Sparapani, and sandiburg press

ISBN 978-1-943126-06-4

Front and back cover photos copyright © 2017 by Alison Newberry & Matt Sparapani

Front cover:
Taking in the View over Lake Te Anau, Kepler Track, Fiordland National Park, New Zealand

Back cover:
The Climb up to Clouds Rest, Yosemite National Park, CA (top)
Baby Black Bear, Wonderland Trail, Mount Rainier National Park, WA (middle)
Shepherd Girls above Quebrada Alpamayo, Cedros-Alpamayo Circuit, Peru (bottom)

Unless otherwise stated, all interior photos by Alison Newberry & Matt Sparapani

Published by sandiburg press

www.sandiburgpress.com

SAFETY NOTICE: This book describes physically challenging activities in remote outdoor environments which carry an inherent risk of personal injury or death. While the authors and sandiburg press have made every effort to ensure that the information contained herein was accurate at the time of publication, they are not liable for any damage, injury, loss, or inconvenience arising directly or indirectly from using this book. Your safety and health during preparations and on the trail are your responsibility. This book does not imply that any of the activities described herein are appropriate for you. Make sure you fully understand the risks, know your own limitations, and always check conditions as they can change quickly.

Contents

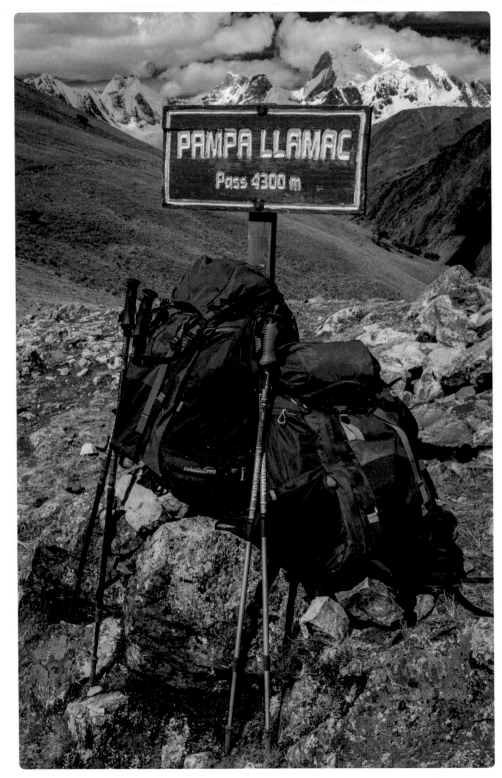

Figure 1

Pampa Llamac Pass
Cordillera Huayhuash,
Andes, Peru
*DSLR, f/16, 1/60, 24mm,
ISO 200*

Welcome

Hiking and photography are each rewarding activities in their own right, but combining the two can often be a challenging endeavor. The primary purpose of each activity would seem to run contrary to the other. Hiking is often about moving under your own power from one place to another with the goal of completing the journey. Photography, on the other hand, implies slowing down and stopping to capture a beautiful moment – in effect, a pause in the journey.

Additionally, the equipment required to enjoy each activity well may, at first, appear to be at odds. Hiking efficiently and comfortably requires lightweight gear with adequate room in your pack for food, water, first aid kit, and rain gear, leaving little room for camera equipment. Taking high quality photographs can involve lugging heavy, bulky (not to mention expensive) gear, such as a DSLR camera, multiple lenses, and a sturdy tripod, none of which lends itself well to walking for miles over sometimes difficult terrain.

We all, however, want to document our hiking experience, either for personal memories or to share with others, and we should want to do this well, producing high quality images that accurately express the beauty that we encounter along the trail and tell the story of our adventure. So, how do we effectively combine both pursuits?

The goal of this book is to walk (pun intended) you through the challenges in hiking photography and offer solutions. We discuss the options available for camera equipment and offer tips for how to take better photographs on the trail. We also offer suggestions on how to improve your photos in post-processing once you get back home. We hope that by reading this book, you will be able to make better decisions both before you leave home and on your hike that will help create amazing photos and lasting memories of your journey.

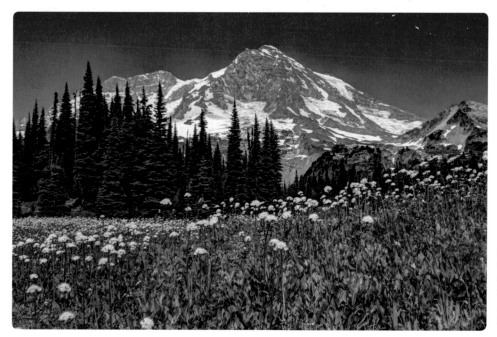

Figure 2

Mount Rainier and Wildflowers

Wonderland Trail, Mount Rainier National Park, WA

DSLR, f/18, 1/15, 26mm, ISO 100

Introduction

Hiking photography can be challenging for a number of reasons. Typical challenges in the field that will be addressed in this book include: choosing what camera gear to take (and what to leave behind), protecting your gear from the elements, managing different lighting conditions, charging batteries, and photo storage. Once you have answered these basic questions, the next challenge is identifying great subjects and ideal times and locations to shoot. This book guides you through many types of hiking photography and offers tips on how, when, and where to shoot a variety of subjects, from landscapes to wildlife. Finally, we offer advice on how to organize, process, and share your images once you get home.

Successful hiking photography involves a number of factors. First, be clear about your photographic goals. Is your primary intention to take snapshots that record personal memories to share with friends and family? Are you hoping to print the images and display them on your walls at home? Or do you hope to gain a larger audience for your craft through photo sharing websites or blogging? Identifying your motivation as a photographer will help you decide what equipment is right for your journey. Second, take time to research your hiking destinations. Having a clear sense of what the primary points of interest are and where and when to find them will help you use your time on the trail efficiently and maximize the photographic opportunities. Third, know yourself as a hiker. Are you a short-range day hiker or are you comfortable backpacking into the wilderness? What distance is reasonable for you to cover on a typical day? How strenuous a trail can you manage? How much weight are you capable of carrying? Knowing your physical limitations will help you plan enjoyable and achievable hikes that strike the right balance between hiking and photography.

Figure 3 (left)

Matt Enjoying the View from Caracara Pass

Cedros-Alpamayo Circuit, Huascarán NP, Peru

DSLR, f/22, 1/80, 16mm, ISO 400

Figure 4 (right)

Alison Capturing a Moment along the Trail

Wonderland Trail, Mount Rainier National Park, WA

Compact, f/8, 1/6, 5.9mm, ISO 200

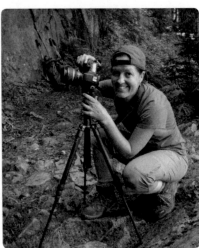

As teachers, we are blessed to have weekends, holidays, and summers free to explore this amazing planet. We have been traveling, hiking, camping, and canoeing together for 25 years and have always enjoyed photography. Our first serious introduction to outdoor photography was at an Audubon Society photography camp we attended in Maine. It was there that we first learned to slow down and pay attention to nature and where we first began to learn the craft of taking better photographs. We joined a nature camera club many

years ago and began to learn from fellow outdoor photographers where, when, and how to shoot various nature subjects. Over the past decade, we have been fortunate to travel all over the world and document our journeys through the camera.

In recent years we have done so on foot, hiking both short and long distances, often with a backpack, for days on end. Our hiking adventures have taken us to Patagonia in both Chile and Argentina, Mt. Kilimanjaro and Mt. Meru in Tanzania, Iceland, the Himalayas of northern India and Nepal, Machu Picchu and the Cordillera range in Peru, the Rocky Mountains of the Western U.S. and Canada, the Olympics and Mount Rainier in Washington, and the John Muir Trail through the High Sierras of California. We document many of our travels through our blog, *Take A Hike Photography*, which is "dedicated to exploring and documenting our natural world". We wrote the *Plan & Go Guide to Hiking the Wonderland Trail* (Sandiburg Press 2015). We also teach and present programs on various photographic topics to camera organizations in the Chicago area.

Figure 5

Matt & Alison Posing in front of Mount Rainier

Wonderland Trail, Mount Rainier National Park, WA

DSLR, ƒ/18, 1/30, 17mm, ISO 200

This book is designed to be a comprehensive guide for all aspects of hiking photography. Chapter 1 reviews basics of photography by discussing important topics such as exposure, lighting, and composition. Chapter 2 addresses camera equipment by reviewing options on the market to help you decide which camera is right for the type of hiking photography you wish to accomplish. Chapter 3 addresses popular subjects for the hiking photographer by discussing common situations encountered on the trail. We also offer many tips and tricks for composing high quality images with maximum interest. Chapter 4 discusses what to do with your images once you get home and addresses various post-processing techniques. In addition to offering advice on how to store, share, and organize your digital files to maintain a good workflow, we also explain common corrections and enhancements that can be made using photo editing software. Finally, the Appendices offer a Quick Guide for Trail Photography, some words about the ethics of nature photography, as well as additional print and web resources to help you continue your photographic journey.

1. Reviewing Photography Basics

Show off a stunning photograph and often the first response you receive is "Wow! That's a great photo. What kind of camera do you have?". This always strikes us as odd – as if all you have to do is buy the right camera, point it at a beautiful scene, and click. Great photography has very little to do with the camera and much more to do with how you go about capturing an image. Photography is an art, and it begins with knowing how to skillfully make use of two important tools: your eye and your camera. This takes practice. Photography is, first and foremost, about training your eye to read the light and taking advantage of optimal situations. You must also learn how to use your camera as a tool designed to achieve proper exposure. Finally, you must cultivate your sense of composition by honing your awareness of the beauty found in nature. If you understand the importance of light, exposure, and composition, you can achieve great results regardless of what kind of camera you have.

in this chapter:

» **Goals & Preparation**

» **Light**

» **Exposure**

» **Sharpness**

» **Focus**

» **Photo Composition**

Figure 6 (opposite)

Using Live View to Compose a Shot

Garden of the Gods Wilderness, IL

Compact, f/1.4, 1/80, 4.7mm, ISO 80

Goals & Preparation

When you go for a hike, what is it that motivates you? Do you enjoy being outdoors and getting some exercise in an inspiring location? Do you want to unplug from the world, slow down and immerse yourself in the calm of nature? Or are you perhaps hoping to get off the beaten path to a destination not accessible to most people?

Motivation

Whatever your reason for hiking, if you choose to take photos while on the trail, you have a second question to answer: what is your motivation for hiking *photography*? Are you hoping simply to take a few snapshots to share with friends and family to help them appreciate where or with whom you have been hiking? Or are you hoping to capture special moments of you and your loved ones enjoying nature that will be lasting memories and perhaps end up in frames on the walls of your home? You may be particularly motivated by various nature subjects – flowers, wildlife, landscapes – and wanting to capture the beauty of nature, the behavior of animals, or the perfect light in unique and interesting ways. And you may want to share those images with other nature photographers through camera clubs, blogs, and photo sharing sites that allow for critique and discussion. Finally, your motivation may be more professional in nature, if you are hoping to display your images at a gallery or offer them for sale.

Take some time to really consider your motivations for hiking and photography. Your answers will have profound implications for how you prepare for your journey, the choice of equipment you take with you, the types of images you capture, and what you do with them once you get back home. For example, if the camera is along for the ride to simply capture spontaneous snapshots to share on social media, then you may be content to carry a smartphone or lightweight compact camera with basic functionality. On the other hand, if you are hoping to capture particular shots and want to plan your hike around this, you may wish to carry an advanced camera, such as a DSLR or mirrorless camera, with more sophisticated features that give you more creative control over your photography. The type of photography you choose will also affect the time you spend post-processing, whether you devote minimal time to quick fixes or maximum time to comprehensive enhancements. For this reason, it is important to have clear goals and realistic expectations before you set out to hike and photograph.

Research

Time (and timing) is of the essence in all photography. This is especially true for hiking photographers for whom issues such as lighting, weather, and distance to subject are very real factors. Hiking photography can be a frustrating experience if you are not prepared. For this reason, it is important to do your research before venturing out on the trail. Learn all you can about your hiking destination: what are the points of interest and key photo opportunities along the trail? How long will it take you to get there from the trailhead – 5 minutes, 5 hours, or 5 days? What is the optimal time of day and the best time of year to shoot your intended subject? How physically challenging is the trail and what obstacles may you encounter along the way?

Pre-Thinking

Pre-thinking the shoot is critical, too. What equipment will you need to be successful as a photographer? Will you need to carry multiple lenses (wide angle, telephoto, macro) for different subjects? Will you need a tripod to stabilize your camera? How does your photography mesh with your hiking trip as a whole? Are you driving or flying to the trailhead? Are you goinig out for a few hours, overnight, or on a multi-day backpacking trip? What kinds of weather situations are you likely to encounter? What other gear and food will be competing for space and weight in your pack with your camera gear? The more time you spend thinking about, planning, and researching your adventure, the more successful your photography will be. Being forewarned is being forearmed.

Light

Photography, from its Greek roots, literally means "light writing". The very essence of photography is learning how to "write" with light. Understanding how to "read" different lighting situations and appreciate the quality, intensity, and direction of light will be a key factor to your success as a photographer. As a hiking photographer, it is important to realize that most of your light will come from natural rather than artificial sources. Below you will find a description of the advantages and disadvantages of common lighting conditions that the outdoor photographer encounters along the trail, as well as tips on how to make the most of each situation.

Natural light can be broken down into the following categories, based on the time of day in which it occurs. Beginning predawn, these are Blue Hour, Golden Hour, daytime, Golden Hour, Blue Hour, and nighttime. The actual time and duration of these lighting situations will vary depending on the time of year and your location. The farther you are from the Equator, the longer the ideal shooting times of Blue Hour and Golden Hour will be. It is important to research the time of sunrise and sunset before you hit the trail.

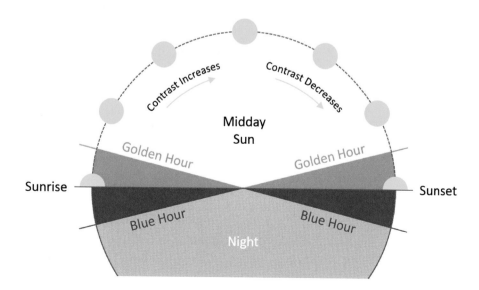

Figure 7

Best Times of the Day for Shooting

Daytime

Let's start with daytime. As you may guess, daytime light refers to the bright sunlight that occurs throughout the day. Daytime is characterized by strong, white light cast from above the subject. As the sun rises higher in the sky, the quality of light becomes less colorful, less flattering, and less desirable to the photographer. Scenes tend to appear washed out, and colors are less vibrant. Be aware that daytime light occurs not just at midday but for the vast majority of the day. It extends from approximately an hour after sunrise until an hour before sunset.

Of course, this is the time of day when most hikers find themselves out on the trail, and so the challenge is learning how to get eye-pleasing shots when the light is working against you. The position of the sun creates harsh shadows that can make getting a proper exposure in your camera more difficult. The range between the intense light and dark shadows is often too much for the camera to handle. The light areas of the scene appear too bright while the shadows and darker areas register as pure black. So, how do you handle this?

Look for scenes that are evenly lit and have few shadows. If that is not possible, try to keep your main subject out of the shadows, so that it does not get lost in a sea of black. Put a pair of "sunglasses" on your lens by using a circular polarizing filter. This handy accessory can help restore color and definition to washed-out scenes, making it your number one weapon of choice during the midday. Think creatively. Shadows can be used to great effect. HDR photography can also be an effective solution in high-contrast situations typical of daytime light.

On the plus side, daytime light is strong enough to guarantee fast shutter speeds, so you can keep that tripod strapped to your pack and revel in the opportunity to shoot handheld for a change. This may also be a good time to try to get those fun action shots where you catch your hiking buddies jumping in mid-air into that unbelievably blue lake. Be sure to take advantage of the opportunity that bright conditions like this afford to get shots with large depth of field. When taking photographs with your hiking buddies in them, remember that hats worn to shield the midday sun will cause extreme shadows across faces. Sometimes shots of hikers with their backs to the camera, overlooking a gorgeous vista for example (Figure 8, bottom), work better than a faceless person looking at the camera (Figure 8, top).

As a general rule, daytime is a good time to put the camera away and accomplish other tasks – make miles to your next photo opportunity, relax and take a well-deserved nap, or even cool off with a refreshing swim in an inviting lake. Use this time to scout photography locations for later. While midday light is certainly not ideal for photography, do not be dissuaded from taking photos that appear pleasing to you. You can still get great shots that tell the story of the trail. If a scene is truly remarkable, try to come back under better lighting conditions.

Figure 8 (top & bottom)

Enjoying the View from Selden Pass

John Muir Trail, John Muir Wilderness, CA

Compact, f/8, 1/500, 4.7mm, ISO 100

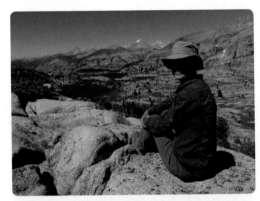

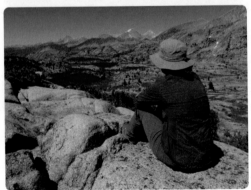

Golden Hour

Golden Hour refers to approximately the first hour of daylight after sunrise and the last hour before sunset when there is soft, direct sunlight falling on your subject. During this time, the sunlight has a warm, golden quality that is especially beautiful in nature photography. The low angle of the sun at this time creates long shadows that add dimension to your subjects. Golden Hour light is the "secret sauce" that can make your photographs stand out from all the rest.

Golden Hour does not last for long, so this is where your research and planning will pay off. Make sure you know where and when the sun will rise and set each day. Apps, weather websites, or even local newspapers can help you figure this out. Golden Hour light is ideal for shooting stunning landscapes. Scout your location in advance if possible. Know the direction of the sun. Is your subject better as a morning or an evening shot? Pack your bags with all your equipment, including a tripod, well ahead of time. Determine how long it will take you to get to your destination and set up before the sun rises or sets so you are ready. Because the lighting is changing quickly, bracket your exposures to improve your chances of capturing this magic moment.

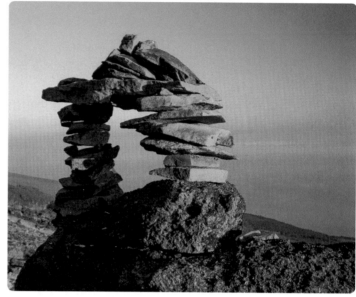

Figure 9

Golden-Colored Cairn Arch

Kilimanjaro National Park, Tanzania

DSLR, f/10, 1/40, 28mm, ISO 400

Nature photography purists will tell you that there is no point in photographing outside of Golden Hour, and you should just pack your camera away during the rest of the day. While we certainly wish that all of our photos could benefit from the flattering light of Golden Hour, it would be difficult for the hiking photographer to impose such restrictions on his or her ability to document their experiences on the trail. Having said that, the sunlight during Golden Hour can be magical and can turn almost any scene into a stunning photograph. Do all in your power to be out on the trail with your camera clicking during this short window of time.

Blue Hour

Many photographers overlook Blue Hour, which refers to the short period of time just before sunrise and just after sunset when the sun is below the horizon and not casting direct sunlight on your subject. In the morning, the sky begins to lighten before the sun crests the horizon. The opposite happens in the evening, after the sun sets below the horizon. During this time, the sky can become an intense blue, while the indirect light of the sun, ranging in color from purple to orange to pink, can be reflected onto your subject to create a spellbinding scene. There are no shadows or harsh light to deal with, but there is still enough ambient light to colorfully illuminate your subject. The occurrence of Blue Hour lasts at most between 20-40 minutes and is greatly affected by weather conditions. Clouds tend to congregate on the horizon and frequently eliminate the possibility of Blue Hour light.

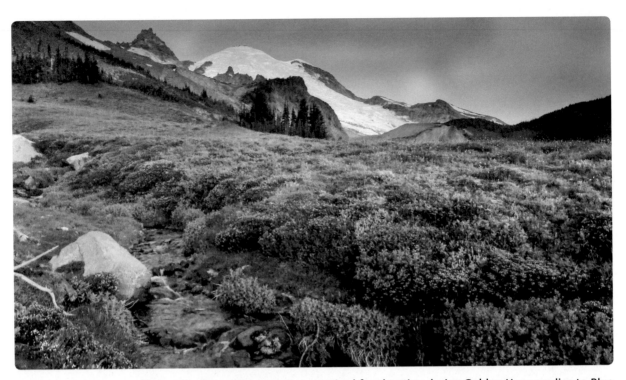

Figure 10

Sunrise at Summerland

Wonderland Trail, Mount Rainier National Park, WA

Compact, f/7.1, 1/10, 4.7mm, ISO 400

All the planning and preparation required for shooting during Golden Hour applies to Blue Hour as well. With even less light for the camera to work with, it is absolutely essential to shoot from a tripod during Blue Hour. Using the self-timer or cable release can help further reduce camera shake. Shoot in RAW and bracket your exposures to improve your chances of capturing this dramatic light. Work quickly as the light quality changes rapidly. If you are photographing a location during sunrise or sunset, do not forget about the possibility of shooting during Blue Hour. Sometimes sticking around for a few minutes after sunset can really pay off. Be sure to pack your headlamp for getting home safely.

Nighttime

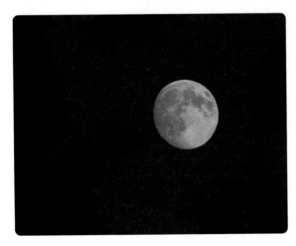

You may think that once the sunlight is totally gone that your shooting day is done, but that would be a mistake. The moon and stars provide a natural source of light, too, that can make for rewarding nighttime photography, particularly for the hiking photographer. The moon reflects sunlight and can be a subject unto itself, but it also can illuminate other subjects as well — the bigger the moon, the more ambient light available. Stars also make a fantastic subject on clear nights when the moon is absent — the blacker the skies, the more visible they are. If your hiking takes you far from the light pollution of civilization, why not take advantage of the opportunity for nighttime photography?

Figure 11 **Supermoon above Summerland** Wonderland Trail, Mount Rainier National Park, WA *DSLR, f/11, 1/80, 300mm, ISO 400*

Other Lighting Conditions

In addition to understanding the quality of natural light available throughout the day, it is also important to be aware of how different lighting and weather conditions affect your photography.

Overcast Light

Overcast light is produced when clouds blanket the sky and block out direct sunlight. The cloudy conditions associated with overcast light generally make an unappealing, featureless background for landscapes, but overcast lighting can produce advantageous shooting conditions for certain subjects. Clouds diffuse bright sunlight, making colors appear richer and less blown out. Contrast between dark and light elements in a scene is reduced, minimizing shadows and evening out exposure.

Subjects that appear more pleasing in overcast light include flowers, forest scenes, and waterfalls. This is also a good time to take pictures of your hiking buddies as you generally do not have to worry about harsh shadows obscuring faces. Whatever the subject, be sure to shoot with a background that does not include too much sky since overcast conditions typically do not add an element of interest to your photo. In general, higher ISOs will be needed to compensate for the loss of light. Pay attention to your histogram, if possible, to insure proper exposure. Overcast lighting can be your friend when shooting around midday.

Weather Conditions

Certain weather conditions can present a particular challenge to the hiking photographer. Rain, fog, snow, and everything in between can significantly alter lighting conditions by reducing ambient light and making it difficult to pull your camera out at all. Still, there are ways to protect your camera and photograph in difficult weather conditions, even when the elements conspire against you.

It is important to protect your gear from water, in whatever form it comes, by using an umbrella, a waterproof bag, or other specialty gear designed to repel water. Rain can disrupt your photography entirely, but pay attention to the time period before and after a thunderstorm. High thunder clouds can bounce the light of the sun in unexpected ways to

Figure 12

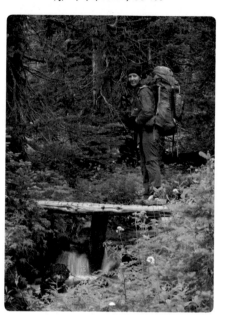

Crossing a Creek

Northern Loop Trail, Mount Rainier NP, WA

Mirrorless, f/10, 1/3, 50mm, ISO 400

Figure 13

Breaking through the Fog

Wonderland Trail, Mount Rainier NP, WA

DSLR, f/11, 1/25, 20mm, ISO 400

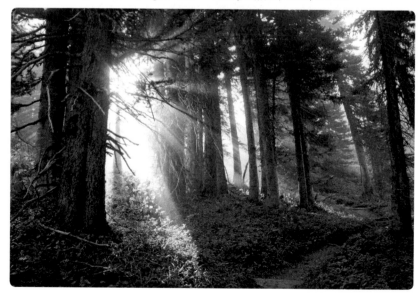

create dramatic lighting conditions as vibrant and intense as Golden Hour. Just be careful if lightning is striking in the vicinity! Early morning fog and falling snow can create a moody, atmospheric effect that helps tell a story. Do not rule out photography during less than ideal weather.

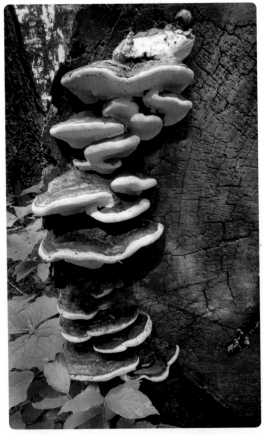

Artificial Light

As a photographer, sometimes it is necessary or advantageous to make use of artificial light to properly expose a subject or illuminate a darker area in the composition. Most hikers cannot afford to carry the extra weight of a dedicated flash unit that mounts to the hot shoe on a DSLR. Unless you are hiking for short distances and know that you need this accessory to pull off a shot, consider using the built-in flash on your camera instead.

When shooting pictures of people whose faces appear significantly in shadow due to the lighting conditions, add flash to brighten up their faces. Pay attention to your distance from the subject as the built-in flash has a limited range. Be careful not to be too far or too close when using the built-in flash and watch out for unintended glare and redeye. Many cameras have a redeye reduction feature to counteract this problem when photographing animals or people.

Be aware that using flash at full strength often looks artificial in nature photography. Most compact cameras, DSLRs, and mirrorless cameras allow you to control the strength of the camera's flash output by -½ or -⅓ stops of light to subtly fill in light where needed. When shooting flowers, mushrooms, or bracket fungi in a dark forest, adding a little bit of fill flash to supplement the natural light in the scene helps to open up the shadows and make your subject pop.

Figure 14

Bracket Fungus Detail

Wonderland Trail, Mount Rainier National Park, WA

Compact, f/5.6, 1/15, 4.7mm, ISO 400

In lieu of flash, you could also use a gold or silver reflector to bounce light into darker areas. Small, pocket-sized versions are a convenient option for the hiking photographer. Flashlights can also be used to provide additional light. If you are engaging in nighttime photography, use your flashlight to "paint" a subject you would like to draw attention to or to illuminate your tent from the inside.

Exposure

Capturing an image with the correct exposure is an essential component of all good photography. There are three major factors that affect the exposure of the image: ISO, shutter speed, and aperture. These elements are often referred to as the "exposure triangle". Their relationship is mutually interdependent. Changing the settings for one requires you to adjust the settings of the other two. Finding the correct balance of ISO, shutter speed, and aperture achieves proper exposure.

ISO

In digital photography, ISO is an indication of the camera sensor's sensitivity to light. ISO is measured in numbers: 100, 200, 400, 800, and so on. Each increase in ISO number doubles the sensor's light sensitivity. The lower the ISO, the less sensitive or "slower" the sensor is. The higher the ISO, the more sensitive or "faster" your sensor is. Higher ISOs translate to faster shutter speeds, which allow you to shoot handheld. Shooting with a higher ISO can eliminate the need for a tripod. While this is more convenient, the tradeoff is that higher ISOs can produce "noise", which makes images appear grainy. Generally, noise begins to occur at ISOs of 1600 or higher, but this can vary greatly depending on the quality of your camera. Lower ISOs translate to sharper-looking images.

A good rule of thumb to follow in nature photography is that it is best to keep your ISO as low as lighting conditions will allow to ensure that your images will look as crisp as possible. An ISO of 100 is ideal but not always realistic. Considerations that may contribute to your choice of ISO include the time of day you are shooting, whether your subject is moving or stationary, and whether or not you are using a tripod.

We already know that the light found at sunrise, sunset, and throughout Golden and Blue Hours makes for stunning nature photography, but the low light at these times of day requires higher ISOs. Using a tripod to keep your camera still during these periods allows you to keep your ISO lower. If you are not carrying one on the trail, increasing your ISO may still allow you to get the shot when shooting handheld. When subjects like fellow hikers and animals are on the move, increase your ISO to help prevent blur. If your subject is at rest, a lower ISO may work just fine. When shooting landscapes, remember that windy conditions can produce undesirable movement in flowers and foliage. Using a higher ISO may be the best way to "freeze" moving plants and leaves on windy days.

Aperture

Light passes through an opening in the shutter called the aperture. The size of the opening is measured in f-stops (f/4, f/5.6, f/8, etc.). You control how much light is allowed to reach the sensor by setting the aperture. Each change in f-stop doubles or halves the size of the opening, thereby doubling or halving the amount of light allowed in. Aperture can be confusing to the beginner photographer because it is somewhat counter-intuitive. The lower the f-stop number, the larger the opening and the more light that enters the camera. The higher the f-stop number, the smaller the opening and the less light that enters the camera.

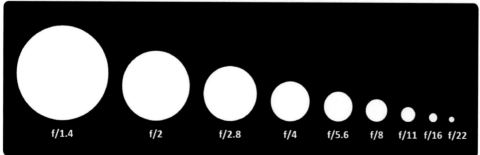

Figure 15
Aperture Overview Chart

Aperture also controls the amount of a photograph that will appear in focus from foreground to background. This is known as depth of field. Images taken with high f-stops have a large depth of field with a greater range of the photograph in focus. When taking photographs of landscapes, higher f-stops are necessary to ensure that the entire scene is in focus. Setting your aperture to f/22 or higher is a good rule of thumb, but be aware that this will often result in a slow shutter speed, particularly in the low-light conditions of Golden Hour when landscapes are often most impressive.

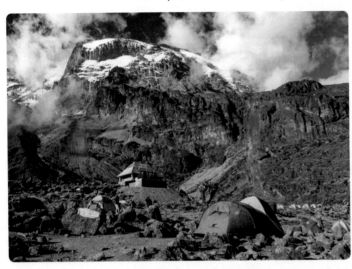

Figure 16 (left)

Barranco Camp
Kilimanjaro National Park, Tanzania
DSLR, f/16, 1/80, 22mm, ISO 400

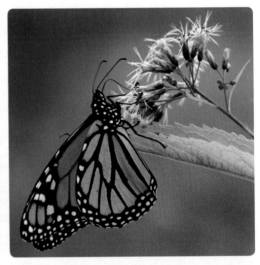

Figure 17 (right)

Monarch on Pye Weed
Roan Mountain State Park, TN
DSLR, f/8, 1/400, 220mm, ISO 400

Large apertures of f/5.6 or lower produce a shallow depth of field in which only a small range of the photograph is in focus. Subjects within the range of focus will appear sharp, while everything else will be out of focus or blurry. This can be particularly attractive when shooting wildlife or flower portraits where a shallow depth-of-field can help the subject to stand out from its background. Keep in mind that to get a background that is completely blurred, there must also be physical separation between the subject and its surroundings. Sometimes, this can be achieved by shifting your position slightly, particularly when shooting with a telephoto lens.

It is important to know that, along with aperture, the distance of the subject from your camera greatly affects depth of field as well. Focusing on objects that are closer to the camera will result in a narrower range of focus than objects that are farther away. When shopping for lenses for your DSLR or mirrorless camera, pay close attention to the maximum aperture of the lens. This refers to the largest opening that the lens aperture can be set to. "Fast" lenses with low apertures are generally more expensive but can be particularly useful to the hiking photographer who will definitely appreciate the flexibility they allow when shooting in low-light conditions.

Shutter Speed

When you press the shutter-release button on your digital camera, the shutter curtain opens to reveal the camera's sensor, letting light in and exposing the image. The amount of time the shutter is open is called the shutter speed. The less time the shutter is open, the less light is allowed to reach the sensor. The more time the shutter is open, the more light is allowed to

reach the sensor. Shutter speed is measured in seconds and more commonly in fractions of a second (1, ½, ¼, ⅛, 1/15, 1/30, 1/60, 1/125, 1/250, 1/500, etc.). The larger the number found in the denominator, the faster the shutter speed. Each increase in shutter speed decreases the amount of light entering the camera by approximately half. Each decrease in shutter speed approximately doubles the amount of light entering the camera.

When choosing shutter speed, it is important to consider how much light is available, whether or not your subject is moving and how you want to capture that movement. For the hiking photographer who must make use of changing natural light conditions throughout the day, shutter speed settings will vary considerably. Optimal shooting times early in the morning and late in the day have softer light, requiring longer shutter speeds. Be aware that it is difficult to hold the camera steady at a shutter speed slower than 1/60 of a second, so you will need to increase your ISO or open your aperture wider to achieve a minimum shutter speed of 1/60 of a second during low-light conditions. Alternatively, use a tripod to stabilize your camera.

Figure 18

Lyell Fork of the Tuolumne River

John Muir Trail, Yosemite National Park, CA

DSLR, f/22, 3.2s, 23mm, ISO 100

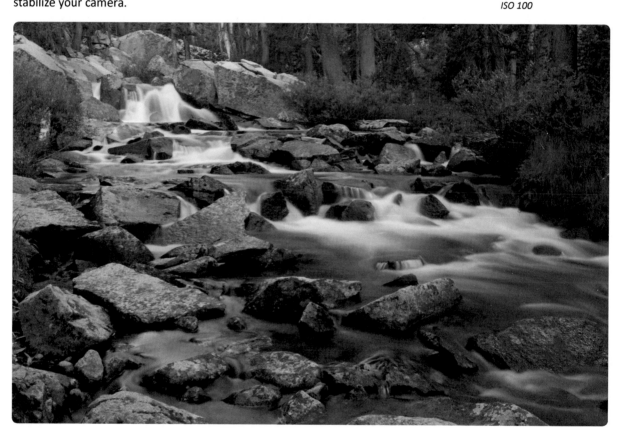

When shooting with telephoto lenses, faster shutter speeds are necessary to compensate for camera shake that is amplified by the high magnification of the lens. As a general rule, always use a minimum shutter speed equivalent to the inverse of the focal length of the lens. For example, if you are shooting with a 400mm lens, a minimum shutter speed of 1/400 of a second would be required to achieve adequate sharpness. If a subject is moving, choose your shutter speed based upon whether or not you want to show motion or freeze

movement in your photograph. Using a slow shutter speed when shooting fast-moving water found in rivers, waterfalls, and seascapes creates a soft, blurred effect that is particularly lovely. Slow shutter speeds can create a cool effect with moving clouds and are also required to capture star trails in nighttime photography. Using fast shutter speeds will freeze the motion of wildlife encountered on the trail or the action of your fellow hikers.

Exposure Settings

Now that we understand the basics of the exposure triangle, let's take a look at how to control your camera's exposure. While these settings may seem purely technical, making use of them can have a profound effect on the artistic side of your photography. All cameras have the ability to determine exposure automatically, but automatic settings may not always produce the best possible image. Putting your camera in manual mode and learning how, when, and why to adjust its ISO, shutter speed, and aperture will allow you to take control of the creative decisions necessary to take your photography to the next level. A sound understanding of all three settings is the foundation for good photography. Therefore, it is useful to understand a few important features of your camera that help you achieve proper exposure in an image.

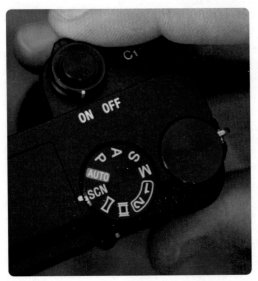

Figure 19

Shooting Mode Dial

DSLR, f/2.8, 1/400, 30mm, ISO 400

Choose your Shooting Mode

There are many ways to adjust exposure, depending on what mode you are shooting in. More advanced cameras allow you to shoot in fully automatic, manual, aperture priority, and shutter speed priority modes. The shooting mode you choose plays a role in determining the best method of achieving exposure compensation. In automatic mode (Auto), the camera chooses all the exposure settings for you, whereas in manual mode (M) you choose the ISO, shutter speed, and aperture. In aperture priority mode (A or Av), you set the aperture and ISO, and the camera adjusts the shutter speed to achieve proper exposure. This is useful when your primary concern is depth of field or how much of the image you want to be in focus. In shutter speed priority mode (S or Tv), you set the shutter speed and ISO, and the camera adjusts the aperture to achieve proper exposure. This is useful when your primary concern is capturing the action of a moving subject.

Read the Histogram

A more sophisticated way to understand exposure is to learn how to use your camera's histogram. A histogram is a graphical representation of the tonal values, or relative brightness, of your image ranging from black (0% brightness) to white (100% brightness). A histogram displays dark tones, such as the blacks or shadows in an image on the left, midtones, such as grays, in the middle, and highlights or bright white tones on the right. Like a bar graph, the height of each line represents how much information is recorded at a particular tonal value. Reading the histogram is extremely helpful as you are shooting in the field to determine if you are properly exposing an image. Even if your image appears correctly exposed on your LCD screen, the histogram will more accurately confirm if this is actually the case.

Underexposed	Properly Exposed	Overexposed
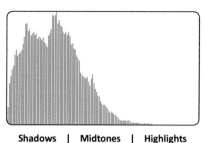	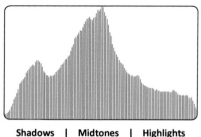	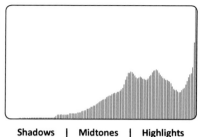
Shadows \| Midtones \| Highlights	Shadows \| Midtones \| Highlights	Shadows \| Midtones \| Highlights
Little to no information recorded for midtones and highlights. Lines clustered in shadows.	Sufficient information recorded at all tonal values, resulting in balanced histogram.	Little to no information recorded for midtones and shadows. Clipping of highlights occurs.

The middle diagram above shows an ideal histogram in which there is a full range of digital information recorded from the left edge to the right edge with no gaps. In other words, your camera is recording details in the dark shadows, and nothing appears blown out or featureless in the brightest areas of your image. An ideal histogram will cluster the highest lines, the ones with the most information, generally in the middle. If these lines appear either too far to the right or too far to the left, the image is either over- or underexposed. If the lines touch the right or left side, information is being lost, which is often referred to as "clipping". Most cameras can display the histogram for you to view after you have taken an image. Some cameras offer a live histogram that appears on one side of your LCD screen as you are composing an image. Either way, learning how to read your histogram will indicate whether an image is properly exposed or suggest the need to compensate while you are still in the field. Remember, the goal is to get the image right "in the box".

Figure 20

How to Read a Histogram

Use the Exposure Level Indicator

Most advanced cameras display a graph known as an Exposure Level Indicator (ELI) when you look through the viewfinder or on the LCD screen.

$$-3..2..1..\overset{0}{\underset{\blacksquare}{}}..1..2..+3$$

Figure 21

Exposure Level Indicator

DSLR cameras also show this graph on the top of the camera body. The ELI is activated when the shutter button is pressed halfway. The graph represents the Exposure Value (EV) of the scene you are shooting. EV is a combination of the ISO, shutter speed, and aperture and indicates whether your camera settings are allowing enough light in to properly expose an image. When the needle on the diagram is at +/-0EV, this indicates that the exposure settings that you have chosen will produce an image that is theoretically properly exposed. This may not actually be the case, though, so make a habit of looking at the back of your camera and checking your histogram.

If your histogram indicates that information is touching either the left or right side, clipping is ocurring. You should adjust your exposure to compensate for this by moving the exposure needle to the right or left to over- or underexpose. This is known as exposure compensation. Each increment on the ELI represents +/- ⅓ of a stop of light. The ELI displays a range of exposure from 3 full stops underexposed (-3EV) to 3 full stops overexposed (+3EV). Knowing how to use the ELI is essential for refining your exposure.

Enable the Highlights Feature

A simple approach to understanding exposure is to enable your camera's highlight warning in the menu settings. This will cause any overexposed elements in the scene to flash black and white. These are often referred to as the "blinkies" by photographers. After you have taken an image, examine the results by looking at the image on the LCD screen of your camera. If the highlights are blinking, this means that those areas of your image are blown out, and some correction will be needed to achieve proper exposure.

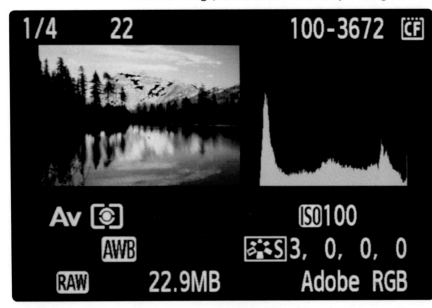

You can make adjustments right then and there in the field and shoot again to eliminate blinkies and get it right "in the box". No amount of post-processing can recover lost detail in blown out areas of your image. Although the highlights feature is a useful tool, be aware that it only warns if your image is overexposed, not underexposed.

Figure 22

Checking Highlights on LCD Screen

DSLR, f/4, 1/100, 70mm, ISO 1600

Ways to Adjust Exposure

You can compensate for exposure by adjusting either the ISO, shutter speed, aperture, or by setting the exposure compensation. If you are shooting in fully automatic mode, you can simply set the exposure compensation to under or overexpose the image by the desired amount, and your camera will tweak the other settings accordingly for all the images you take. If you are shooting in manual mode, you can choose to adjust the ISO, the shutter speed, or the aperture to achieve exposure compensation. If you are shooting in aperture or shutter speed priority modes, when you change either the aperture or the shutter speed, the camera maintains the desired exposure compensation by adjusting the opposite setting.

Our Take

Generally, we shoot in aperture priority mode and tend to slightly underexpose our images to ensure that we capture all the information in the scene. When we encounter tricky lighting situations, we take this a step further and bracket our exposures. Instead of taking just one image at a single exposure level and hoping that we exposed correctly, we take multiple shots of the scene set at different exposure levels. For example, if our initial exposure was set at +/-0EV, we also take one exposure at -1EV and another exposure at +1EV. Of course, this takes a little more time in the field and space on our memory cards, but bracketing greatly improves our chances of getting a shot correctly exposed in the camera. Once uploaded on our computer at home, we view the images on a much larger screen and determine which exposure is best before optimizing it in post-processing.

HDR

HDR or High Dynamic Range photography is a solution to photographing scenes that are overly high in contrast. It is useful when a single shot is unable to capture all the details in an individual exposure due to the extreme range of light and dark in the scene. Instead of a single shot, a series of shots set at different exposures is taken. The multiple exposures are then combined into a single photograph. HDR has become a popular feature on smartphones and compact cameras where the entire process of bracketing and processing is done automatically in the camera when the shutter is pressed. If shooting with a DSLR or mirrorless camera, it is necessary to manually bracket in the field and combine the exposures using software at home.

Why is HDR necessary? The human eye is capable of seeing a much wider range of light than a camera's sensor can capture. When looking at a typical alpine scene, for example, our eyes are able to take it all in. We can make out the details everywhere in the scene, whether it be the snowy, white peaks whose tops are brightly illuminated by the morning sun or the individual trees still in shadow in the foreground where the sun's light has yet to reach. While captivating to your eye, to the camera's sensor this attractive scene is a contrasty mess. The range of light is simply too much for it to handle. Set your exposure to capture those beautiful snowy peaks, and the trees will be lost completely in black shadow. Set the exposure for the dark trees, and the bright mountains and sky will be overexposed. So what is a hiking photographer to do? Difficult scenes like this are made for HDR.

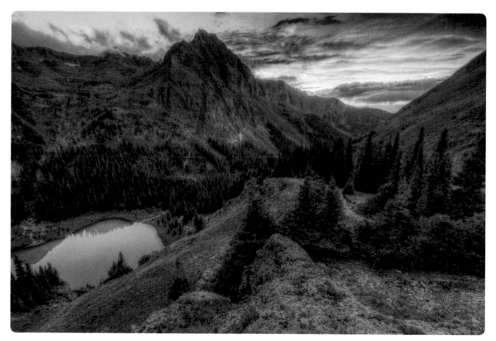

Figure 23

Sunset above Blue Lakes
Mt. Sneffels Wilderness Area, CO
DSLR, f/22, 0.6s, 10mm, ISO 800 (HDR)

While many cameras offer automatic HDR as a feature, doing it yourself manually with a DSLR or mirrorless camera yields superior results and gives you much more creative control over the final product. Here is how it works: The first step is to stabilize your camera. Since HDR photography combines several shots of the scene into one single photograph, proper

image alignment is essential. After setting up your camera and composing your shot, take several photographs while bracketing the exposure. A minimum of 2 different exposures is required for processing an HDR shot, but there is no set maximum number of photos, just as long as the exposures are evenly spaced apart. We typically shoot 3 photographs for HDR processing: one photo that is 2 stops underexposed (-2EV) to capture the highlights, one photo that is properly exposed to capture the midtones (+/-0EV), and one photo that is 2 stops overexposed to capture the dark areas in the scene (+2EV).

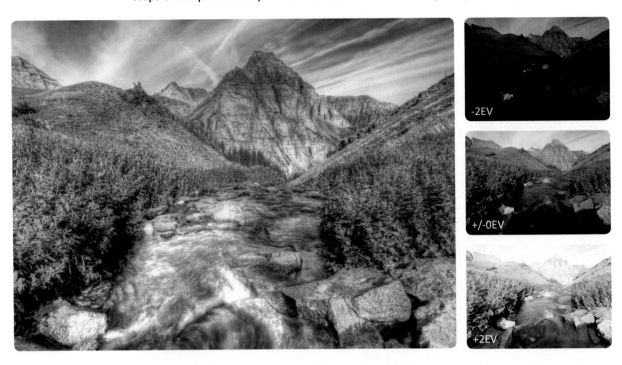

Figure 24

East Fork Dallas Creek (HDR)

Mt. Sneffels Wilderness Area, CO

DSLR, f/22, 1/10, 10mm, ISO 100

Once the images are loaded onto your computer, use HDR software to combine multiple exposures into a single image. There are several software programs available, including Photomatix Pro, Adobe Photoshop, Adobe Lightroom, and Luminance HDR, to do this. The process is simple: select the bracketed exposures, and the program merges them together. Some programs feature a variety of preset styles, from fairly natural to extremely creative, that can drastically alter the look of your photo. Additional post-processing may be needed after the initial HDR conversion has been done to finetune the image. We find that most of our HDR photos usually benefit from adding contrast.

HDR is a relatively recent trend in photography, and most people tend to either love it or hate it. We love the way that HDR photography allows us to capture high contrast scenes, like alpine sunrises and sunsets or sunlit forests, that would be impossible to shoot otherwise. On the other hand, the end result often has an "unreal" look to it that some consider unappealing in nature photography. If you choose to use HDR with your hiking photography, be aware that it is easy to overdo it and produce oversaturated and over-sharpened photographs that are not an accurate representation of what is found in nature. We suggest trying to make your photographs look as realistic as possible.

Sharpness

Sharpness is absolutely critical to producing excellent images in nature photography. Post-processing can help solve many problems that photographers make in the field with areas that are more forgiving, such as exposure, composition, and white balance. Sharpness, however, is one aspect of digital photography that you must get correct in the camera. Camera shake is the most common culprit in blurry photographs, and it occurs most often when shooting handheld. For hiking photographers, handheld shooting is definitely the most convenient option on the trail. Even if you are willing to carry the extra weight of a tripod, you may not always feel like you can sacrifice the time needed to set it up every time you want to take a photograph. Using a tripod is not always practical when you need to make miles on the trail.

If you do choose to shoot handheld, take precautions to help ensure your photos are as sharp as they can be. Good shooting posture plays an important role in minimizing camera shake. Grip your camera firmly with one hand while supporting it from below with the flat palm of your other hand. Stand with your legs spread apart and the elbow supporting your camera tucked into your ribcage. Exhale deeply and wait for the pause between breaths to press the shutter release. You may also look for a way to support your elbows, perhaps on the ground, on a nearby rock, or on an inanimate structure like the railing of a footbridge. It can be helpful to lean against a nearby tree to stabilize your body and reduce unwanted shake. Be aware that a heavy backpack and trail fatigue may make it more difficult to achieve good balance and posture.

Figure 25

Alison Shooting Handheld
DSLR, f/4, 1/640, 16mm, ISO 320

Only shoot handheld when there is sufficient lighting to keep your shutter speed at a minimum of 1/60 of a second. Most people are able to hold the camera still enough at this speed to take pictures with adequate sharpness. On bright sunny days, getting fast shutter speeds should not be a problem, but, in low-light conditions, adjusting ISO and aperture settings may be necessary to compensate for longer shutter speeds. Eventually, you will come to learn that your minimum shutter speed for shooting handheld may be a little faster or slower than this. Remember, too, that the minimum shutter speed needed for sharp images will vary based on what lens you are using. Telephoto lenses will require a faster shutter speed to counteract shake than shorter lenses.

Using a tripod is the easiest way to eliminate shake and get tack sharp photographs, but it comes at a serious price for the hiking photographer. Professional-quality tripods are heavy, bulky, and cumbersome to carry for long distances. Even "lightweight" carbon-fiber tripods that extend to full height can weigh as much as 5 pounds, and that is without the ball head! We often hike and backpack with a smaller travel-sized carbon-fiber tripod that extends to about 4 feet, an adequate height for most situations. When paired with a mini ball head, our tripod weighs nearly 5 pounds, which definitely feels like a luxury when pack weight is a primary concern.

There are much smaller mini-tripods available as well. These can hold lightweight cameras stable without a problem but may not be adequate for heavier DSLR cameras and lenses. Mini-tripods require nearly flat surfaces and can only raise the camera a few inches off the ground, making it difficult to compose many shots. Flexible arm mini-tripods, like Gorillapods, are small and sturdy and allow for more flexibility. Their arms can be bent and flexed in any position to accommodate uneven surfaces such as rocks and boulders, and they can even be wrapped around trees and branches to make up for their lack of height. However, they weigh nearly as much as a traditional travel tripod, which we consider much more useful in the field. Regardless, using a tripod is the best method for getting sharp photographs under any lighting condition and is an essential piece of gear for low-light, nighttime, and HDR photography.

Figure 26

Matt using Tripod
Parque National Los Glaciares, Argentina
Compact, f/8, 1/250, 6.1mm, ISO 100

Even with a tripod, there are still additional measures that can be taken to help ensure your photographs are sharp. The very act of pressing the shutter button creates shake at the precise moment you want to avoid it. A cable release or wireless remote shutter release can be used with many cameras to allow you to trigger the shutter without having to physically touch the camera body, but these must be purchased separately. A cheaper and lighter option is to make use of the camera's self-timer setting. It eliminates shake by automating the shutter's opening after a set number of seconds. Some cameras have both a 2-second and a 10-second self-timer option. Choose the shorter time if available on your camera model. It uses less battery, and you will be amazed at how long 10 seconds can feel when you are waiting for the shot to be fired! If using a DSLR, you can also utilize Mirror Lockup to eliminate the vibration that occurs when the mirror inside the camera flips up to get out of the way of the shutter. Shooting in Live View, i.e., using the camera's LCD screen instead of the viewfinder, also accomplishes this.

If you are photographing landscapes or subjects that are not moving (or hiking buddies that are willing to stand still) and are making use of a tripod, consider using manual focus to improve sharpness. One technique that we use is to put our camera in Live View and then zoom in to maximum magnification to manually focus the shot. Getting a tight focus on a key detail in the scene allows us to get a much sharper focus than relying on the camera's autofocus. You can also make use of the magnification feature when reviewing your photos, too. Before packing up your camera, scrutinize your photo with zoom magnification and take the shot again if it is not tack sharp.

Focus

With tack sharpness as a primary goal, it is also important to give some thought to how your focusing choices can play a role in avoiding blurry photographs. Before pressing that shutter, ask yourself these questions: What do I want to be the point of focus in this photograph? How much of the photo do I actually want to be in focus? What should the depth of field be? How you choose to answer these questions can have a huge impact on the overall look, feel, and quality of your shot.

Most people prefer to shoot in autofocus mode over manual focus as it is usually quicker and easier to let the camera focus for you. Even so, you can exercise some creative control by determining the point of focus of your photograph. What is the most interesting subject in the scene you are shooting? This is the spot where you want to focus your viewer's attention, and it should align with the camera's point of focus. Take note of what your camera is using as the point of focus. Those small boxes that appear when you hold the shutter button down halfway are the focus points, and whatever they are locked on will be in focus in your final photograph. Left to its own devices, the camera will most likely choose to focus on whatever is in the center of the frame, looks most prominent, or is closest to the lens.

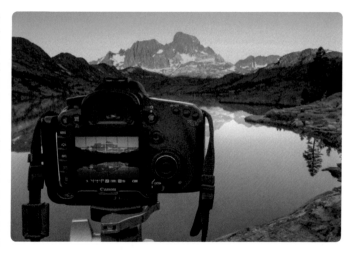

Figure 27 **Photographing Sunset at Garnet Lake** John Muir Trail, Ansel Adams Wilderness, CA *Compact, f/8, 1/250, 6.1mm, ISO 100*

But what if that is not what you want to focus on? More advanced cameras will allow you to change how the camera determines its point of focus. For example, you can decide if you want the camera to use multiple autofocus points or just a single one. Multiple points are useful when taking a landscape photo where you want everything in the scene to be in focus. A single focus point may be more useful when you are trying to make sure that a smaller area of the frame is in focus. This is essential when shooting wildlife, for example, when you absolutely want to make sure the animal's eyes are tack sharp. If you allow the camera to choose its point of focus, it could very well choose the nose, ears, or body instead, especially if they appear closer to the camera than the eyes. Using just one autofocus point can eliminate this common point of focus problem.

Another useful feature is the ability to set which autofocus points your camera uses. Read your camera's manual to learn how you can move this point to a particular spot, a handy option when your primary subject is not in the center of your frame. We find we use this feature most when working from a tripod with a still subject.

If your camera does not offer these features, you can still show it who's boss by using the focus and recompose method. Simply put your main subject in the center of the viewfinder, press the shutter button down halfway and pause. Look for the green box indicating that the point of focus is indeed on your desired subject and, while still lightly pressing down the shutter, recompose your photo and place your subject somewhere new, perhaps off to one side or the other to follow the rule of thirds.

Figure 28

Moose
Cape Breton National Park, Canada
DSLR, f/8, 1/80, 400mm, ISO 400

With your main subject in focus, now it is time to consider your depth of field. How much of your photograph do you want to be in focus? Remember that the size of your lens aperture determines this. A narrower aperture (f/16 or above) produces a greater depth of field, essential for photographing landscapes when you want everything in the scene to be in sharp focus. A wider aperture (f/5.6 or below) produces a shallower depth of field, which can be useful for drawing attention to your subject by limiting what is in focus in the image and blurring the background.

Photo Composition

Composition, simply put, is the difference between a hasty snapshot and a well-thought out photograph. When you take time to compose a photograph and think about how the elements in a scene can be arranged in attractive ways, you are more likely to produce a pleasing image that has lasting impact on the viewer. Composition is a key part of the craft and art of photography. It is important to train your eye to look for attractive details and enticing compositions. There are a number of established composition guidelines and tips which can often be applied to a situation in order to enhance the impact of a scene. Here is a summary of some common composition rules that may be applied in the field.

The Rule of Thirds

When it comes to composition, the rule of thirds is a tried and true technique that can greatly improve your photography. To use the rule of thirds, simply imagine two horizontal and two vertical lines neatly dividing your frame into three columns and three rows as pictured to the left. Use these lines as guides for determining where to place the most interesting or dominant elements of your photo. Be aware that the rule of thirds grid also produces four intersections. Pay special attention to where those lines meet when composing your photographs and try to place the main point of interest of your photo at one of them. When shooting people or animals, it can be very effective to place the eyes roughly at one of these intersections to help create interest.

Why follow the rule of thirds? Generally speaking, it is best to avoid placing your subject directly in the middle of your composition. This splits your frame in two and can create a static image that lacks interest. Instead, shift your subject out of the center to the left or right third (or the top or bottom third depending on your subject) where it is far more compelling. Placing your subject off center creates tension and results in a composition that is more dynamic and

pleasing. It encourages your viewer's eyes to wander through your photograph and engage more with your image, while a centered subject appears static and encourages rest.

The rule of thirds can be used effectively with any subject in almost any photographic situation that you encounter on the trail. In fact, the rule of thirds is so important in photo composition that most cameras have a menu option to display a nine box grid on the LCD screen or when looking through the viewfinder. We strongly advise you to use this feature as it encourages you to keep the rule of thirds in mind when composing your photographs. You will also see the rule of thirds grid displayed when using cropping tools in post-processing, yet another useful reminder of the effectiveness of this composition rule.

Figure 30 **Marmot and Lupine** Golden Gate Trail, Mount Rainier National Park, WA *DSLR, f/8, 1/5000, 285mm, ISO 800*

Balancing Elements

Strictly following the rule of thirds can lead to photographs that appear unbalanced in some cases. Placing your subject off to one side while leaving the other side completely empty often results in a lot of negative space. While this can be attractive and used to an advantage, too much negative space also can make your photograph feel lopsided. When this is the case, look for elements that can be used in your composition to balance the main subject's weight in the frame. Balancing elements in your photograph can be achieved both formally and informally. Emphasizing symmetry is a formal way to balance elements. Some nature compositions like lake reflections, for example, are perfectly symmetrical. They are balanced naturally and can make for pleasing photographs that evoke serenity and calm.

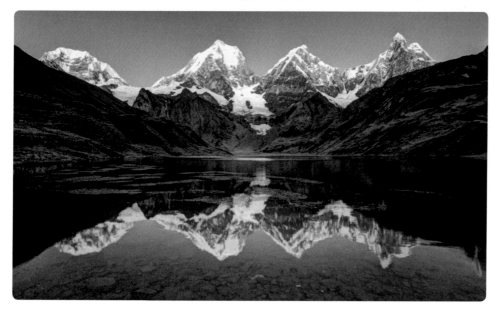

Figure 31

Early Morning Reflections in Carhuacocha

Cordillera Huayhuash Circuit, Peru

DSLR, f/16, 1/4, 11mm, ISO 400

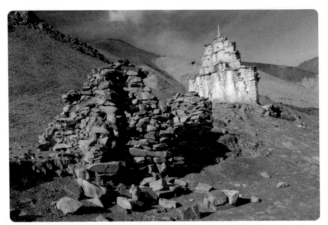

Most subjects, however, are asymmetrical in nature, and so it is the job of the photographer to informally balance the elements included in the composition. Informal balance can be achieved in asymmetrical compositions by placing a secondary subject opposite the main subject. Varying the size (big vs. small), color (light vs. dark), texture (rough vs. smooth) and placement (low vs. high) of the subjects adds interest and helps ensure that the secondary element does not overwhelm your primary subject.

Figure 32 **Chorten and Ruins outside of Rumbak Village**
Ladakh, India *Compact, f/8, 1/640, 4.7mm, ISO 100*

Simplify the Scene

The simplest compositions often make the best photographs. While many subjects appear pleasing to the eye, they lose their impact when photographed. This may occur because the scene is "busy", cluttered with extraneous details that detract from the primary subject. Untidiness competes with your subject and causes the viewer to wonder what he or she is supposed to be looking at. You want your photographs to make a clear impression.

Figure 33

Lewis Monkeyflower Blossoms

Wonderland Trail, Mount Rainier National Park, WA

(left) Compact, f/5.6, 1/25, 4.7mm, ISO 400

(right) Compact, f/2.8, 1/80, 4.7mm, ISO 400

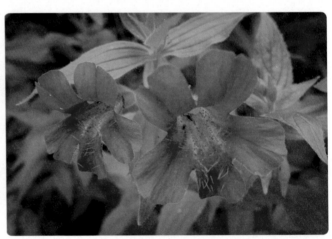

When composing your image, ask yourself if the subject of your photograph is obvious. If not, then it is time for you to simplify the scene. One approach is to shoot with a title in mind for your photograph. Choose your subject and make it the center of attention, though not necessarily the center of the photograph. Isolate the subject in your composition by physically moving closer to it or by zooming in on it. This significantly reduces clutter before it even makes it into your photograph. If something is not adding to your photograph, it is detracting, so try your best not to include it in your composition. Flower scenes, although attractive to our eye, are often busy to the point of distraction. Selecting an attractive bloom and isolating it often results in a more pleasing composition than showing the entire scene.

We often find this tactic useful when shooting landscapes and waterfalls as well, where downed trees or unattractive foliage can detract from the overall beauty of the scene. Another effective method for simplifying the scene is to use depth of field to your advantage. This works best when your subject is separated from its background. Use a wide aperture (f/5.6 or below) to create a shallow depth of field and blur all those pesky, distracting elements behind your subject. This technique works particularly well for portrait shots of flowers, butterflies, birds, and wildlife.

Pay Attention to Your Background

Cluttered backgrounds distract from the primary subject (Figure 34 below). Often, a good photo can turn into a great photo by slightly altering your position in order to find a less distracting background. Even if you cannot eliminate a cluttered background, reducing the depth of field can help blur the background and reduce distraction. This can also be accomplished by using a lens with a longer focal length (Figure 35 below).

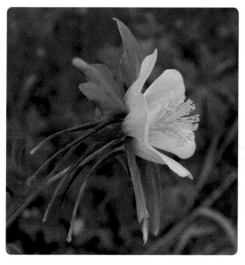
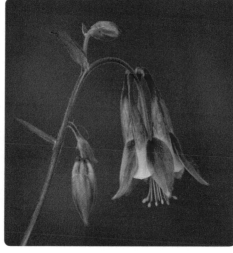

Figure 34 (left)

Rocky Mountain Columbine

Chicago Basin Trail, Weminuche Wilderness, CO

DSLR, f/8, 1/200, 35mm, ISO 400

Figure 35 (right)

Red Columbine Portrait

Kettle Moraine State Park (Southern Unit), WI

DSLR, f/8, 1/125, 375mm, ISO 800

When doing close-up photography, like shooting flowers on the trail, for example, taking a few seconds to clean the scene can really pay off. If possible, physically remove distracting elements, like twigs and dead leaves, that appear in the background of your composition. Pay particular attention to objects that appear white. These often render as bright "hot spots" in the final image and draw the viewer's attention away from the main subject. Large, featureless dark areas in your photo can have a similar effect. They act as a black hole that sucks your viewer's attention away from the main subject.

Be aware of cloudy skies, too, which can appear as a distracting, featureless white element in the background of your photograph. When taking pictures of fellow hikers or wildlife, look out for objects in the background, such as trees, that appear to emerge out of the subject's head. A slight move to the left or right may fix this. Sometimes the subject disappears into the background because it is too similar in color. Look for a contrast in color between the subject and its background when composing your shot to prevent merging. Whenever possible, simplify the background. When it comes to photography, often less is more.

>> Always keep in mind that it is considered highly unethical to destroy living things for the sake of your photograph!

Figure 36

Lobelia Leaf Pattern

Kilimanjaro National Park, Tanzania

DSLR, f/11, 1/25, 55mm, ISO 400

Fill the Frame

Often, composition is less about capturing as much of the scene as possible and more about removing elements to simplify the scene. An effective way to accomplish this is to fill the frame. When your subject fills the frame from edge to edge, it leaves little doubt about what you want the viewer to see. The best way to achieve this is by moving closer to the subject, if the situation allows. If you cannot get close enough, zoom in with a telephoto lens to create a similar effect. If your subject is small, consider using either a macro lens or the flower focus on a compact camera, which minimizes the focusing distance and makes the subject appear larger. This technique can work when capturing landscapes and waterfalls, too. Consider photographing only the most interesting details instead of the entire scene. Isolating a beautiful mountain peak or a single cascade in a busy waterfall may have more impact than shooting a wide shot of the whole scene. The more your subject fills the frame, the less distraction there is for the viewer and the bigger the impact.

Rule of Odds

Odd numbers tend to be more pleasing than even numbers. Look for groups of three subjects rather than two. If you have the option, for example, compose a shot that features three flowers pleasantly arranged rather than just two so that your eye does not "ping pong" back and forth. Odd numbers create a greater sense of balance in a scene, whereas even numbers can often lead to a "split" feel.

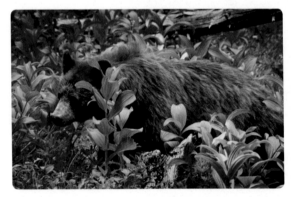

Space to Move

When composing your shot, be careful not to frame the subject so tightly that it appears crowded. When photographing animals and people, it is important to leave space to move. Leave enough room behind the subject to suggest context. Provide active space ahead of your subject for it to "move" into. A duck in a pond needs open water to swim into, a deer in a meadow needs room to walk forward, and a hiker on a trail needs a place to go. Even stationary subjects, such as a bird perching on a branch or a marmot resting on a rock, can benefit from having "look space", an area of the photograph that is free for the subject to gaze into. Be careful not to compose your shot so tightly that your subject has nowhere to look.

Figure 37

Black Bear

Wonderland Trail, Mount Rainier National Park, WA

DSLR, f/9, 1/125, 240mm, ISO 800

Leading Lines

A well-composed photograph engages the viewer by guiding the eyes to wander through the picture. Making use of leading lines in your compositions is an effective way to do this. Leading lines are linear elements that draw the viewer in and help guide them through the

scene. Leading lines are all around us. In nature, a leading line can be a trail, a fallen tree, a river, a shoreline, a valley, or even a row of plants and trees. When used effectively, leading lines guide the viewer to travel from the foreground of the composition to the background and, ideally, to the main point of interest.

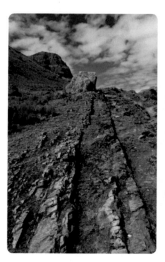 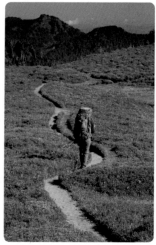 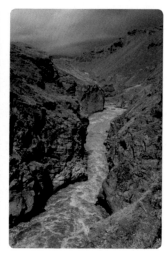

Figure 38 (left)

Rock Tracks
Cordillera Huayhuash
Circuit, Peru
*Compact, f/8, 1/320,
4.7mm, ISO 100*

Figure 39 (middle)

Hiking in Seattle Park
Mount Rainier NP, WA
*Mirrorless, f/13, 1/80,
70mm, ISO 200*

Figure 40 (right)

The "River of Light"
Laugavegur Trail, Iceland
*Compact, f/8, 1/250,
4.7mm, ISO 100*

When composing your photograph, remember to look for elements that can act as leading lines and then play with your angle and perspective to make use of them. Leading lines usually begin at the bottom of the frame and draw the viewer up towards the top of the frame. Try to avoid composing in such a way that the lines emerge directly from the corners of your frame. Leading lines that snake their way through a frame with an S-curve are particularly attractive. Meandering trails and rivers can be used to create pleasing S-curves.

Figure 41

The Climb down to Camp
Cordillera Huayhuash
Circuit, Peru
*DSLR, f/11, 1/25, 55mm,
ISO 400*

Viewpoint

Changing your viewpoint can add impact to your composition and variety to your photographs. Rather than simply shooting from eye level, consider composing from different vantage points to show an interesting and fresh perspective. Work your subject from different angles – from above or below, from one side or the other, or even from behind – and the results may surprise you. Shooting from down low can make subjects appear more imposing or suggest the greater context, while shooting from above can make subjects appear more diminutive or lend a sense of scale. Feel free to move around. Experimenting with changing the viewpoint can be a creative way to compose.

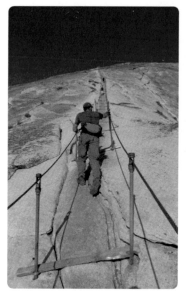 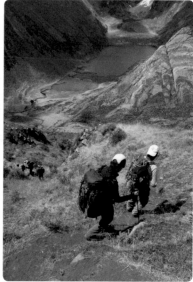

Figure 42 **Climbing the Cables of Half Dome** Yosemite National Park, CA
Compact, f/8, 1/1250, 4.7mm, ISO 400

Orientation

Figure 43

View from Cacananpunta Pass

Cordillera Huayhuash, Andes, Peru

Compact, f/8, 1/800, 4.7mm, ISO 400

Most subjects naturally lend themselves to a particular orientation. Trees, for example, tend to look best as verticals if their height is what you wish to emphasize. Landscapes, on the other hand, are well-suited to horizontal compositions. Most of the time the choice is obvious. Consider the subject and the dominant leading lines. Do they tend to run predominantly up and down or from side to side? The answer will guide you in your initial choice of orientation, but it never hurts to experiment with your composition. Try the same subject as both a vertical and a horizontal. A simple change of orientation can often emphasize unexpected elements or present your subject in a creative way.

Creating Depth

Although photography is a two-dimensional art form, well-composed photographs are able to create a sense of depth that invites the viewer into the scene. There are many ways for the photographer to accomplish this. Create depth by including strong elements of interest in the foreground, middleground, and background. For example, in Figure 44 on the next page, the waterfall acts as a striking foreground element to grab your attention. The stream draws you into the middleground to the tree-lined ridges and, ultimately, to the dramatic peak of Mount Rainier in the background. Framing your subject with natural architectural elements, such as a tree or a rock arch, can guide the eye from foreground to background. Take advantage of dramatic lighting and shadows when they occur. A side-lit peak or a break in the clouds can showcase your subject and add desired dimensionality.

Your choice of lens also plays a role in creating depth. Using a wide angle lens exaggerates perspective and makes objects in the scene appear farther apart from one another. Using a telephoto lens has the opposite effect, stacking elements and making them appear closer to one another. This can be used to your advantage when shooting mountain ranges, when overlapping ridges adds dimensionality to the scene. Zoom in with a telephoto lens to make the overlapping ridges appear stacked.

You can also create depth by changing your perspective. Get low to the ground with your camera to emphasize either the height of your subject or the distance of elements in the background. Incorporate leading lines that draw your eye from the foreground into the middle- and background. In the photo of Maroon Bells in Figure 47 below, the shoreline and its reflection, along with the slope of the mountains on each side of the image, all serve as leading lines that converge at the focal point of the picture in the background, the dramatic peaks of Maroon Bells. Your goal as a hiking photographer should be to create three-dimensionality by immersing the viewer in the magnitude of the scene.

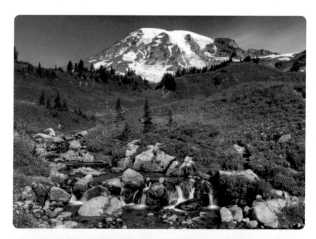 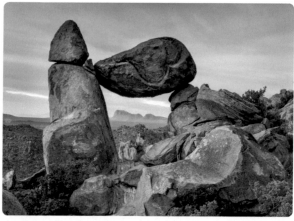

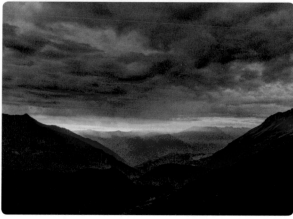 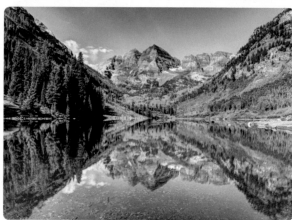

Figure 44 (top left)

The Mountain and Edith Creek
Paradise Meadows, Mount Rainier National Park, WA
DSLR, f/22, 0.8s, 21mm, ISO 100

Figure 45 (top right)

Balanced Rocks
Grapevine Hills Trail, Big Bend National Park, TX
DSLR, f/22, 1/4, 32mm, ISO 400

Figure 46 (bottom left)

Godlight above Hualcayan
Cedros-Alpamayo Circuit, Huascarán National Park, Peru
DSLR, f/16, 1/4, 27mm, ISO 400

Figure 47 (bottom right)

Maroon Lake Reflection
Maroon Bells-Snowmass Wilderness, CO
DSLR, f/22, 1/6, 17mm, ISO 100

Symmetry and Patterns

Using symmetry and patterns can make for eye-catching compositions. As you are hiking, train your eye to look for patterns, and you may be surprised by what you find. Patterns can be found everywhere in nature: in rocks, trees, leaves, pinecones, flowers, shells, spiderwebs, and cacti, for example. Zoom in close and fill the frame from edge to edge to emphasize the arrangement. Symmetry, too, can be a striking compositional element. Butterflies, snowflakes, and ice crystals all exhibit symmetry. Reflections provide another great opportunity to showcase symmetry in nature. In theory, when shooting landscapes, it is best not to have the horizon line split the photo in half. Breaking this rule to emphasize symmetry can be an effective creative choice.

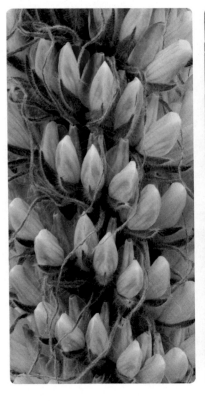

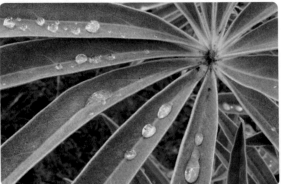

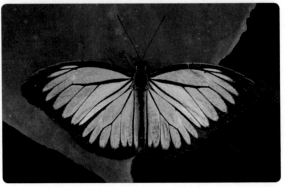

Figure 48 (left)

Lupine Detail

Laguna 69 Hike,
Huascarán NP, Peru

*Compact, f/8, 1/80,
13.7mm, ISO 100*

Figure 49 (top right)

Lupine Leaf with Dew

Laguna 69 Hike,
Huascarán NP, Peru

*Compact, f/8, 1/30,
13.7mm, ISO 100*

Figure 50 (bottom right)

Blue Butterfly

Poring Hot Springs,
Borneo

*DSLR, f/7.1, 1/30, 85mm,
ISO 200*

Be Creative with Colors

Getting creative with colors can add a strong element of interest to your image. Color can be your friend if you know how to use it. Certain color combinations are more pleasing to the eye than others. Complementary colors on opposite sides of the color wheel, such as red and green, blue and orange, and purple and yellow, are particularly striking. Seek these color combinations out in your photographs where possible. Alternatively, concentrating on a single color as a compositional element to create a monochromatic image can be effective, too. Colors can be distracting when they draw the eye away from your primary subject. In this case, you may want to isolate and frame your subject to exclude unwanted colors. Create dominance by making sure your subject is the most colorful object in the scene.

Some scenes benefit from the inclusion of a little color. A waterfall flowing over black rock may appear fairly monochrome, but the inclusion of green plants at the water's edges can make the whole scene pop. When including people in a scene, a splash of colorful clothing helps draw attention to the person and balance out the scene.

Figure 51 **Trailside Berries**
Norway Pass Hike, Mount St. Helens National Volcanic Monument, WA
DSLR, f/5.6, 1/80, 26mm, ISO 400

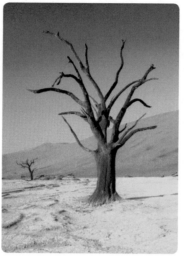

Figure 52 **Dead Acacia**
Deadvlei, Namib-Naukluft National Park, Namibia
DSLR, f/20, 1/80, 26mm, ISO 400

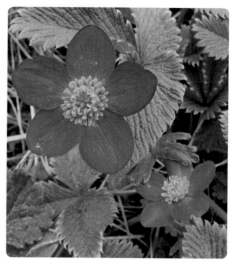

Figure 53 **Purple and Yellow**
Nanda Devi Alpine Trek, Uttarakhand, India
Compact, f/4, 1/500, 4.7mm, ISO 200

Experimentation

All of the suggestions for compositions above are good rules-of-thumb and a great starting point for improving the overall quality of your images. Rules, however, are meant to be broken, and this is certainly true in photography. Once you understand the basic principles of composition and have become skillful with them, it is time to throw out the rulebook and experiment. Sometimes it can be effective, for example, to put the subject directly in the middle of the frame: The horizon line of a lake with a perfect reflection or the center of a daisy with the petals radiating outward may be more pleasing than off-center.

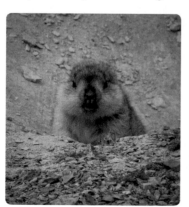

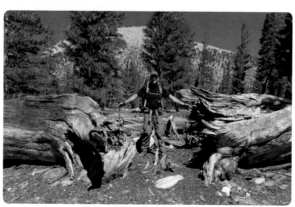

Figure 54 (left)
Baby Marmot below Ganda La Pass
Ladakh, India
DSLR, f/9, 1/160, 85mm, ISO 200

Figure 55 (right)
Split in Two
Pacific Crest Trail, Inyo National Forest, CA
Compact, f/5.6, 1/500, 4.7mm, ISO 100

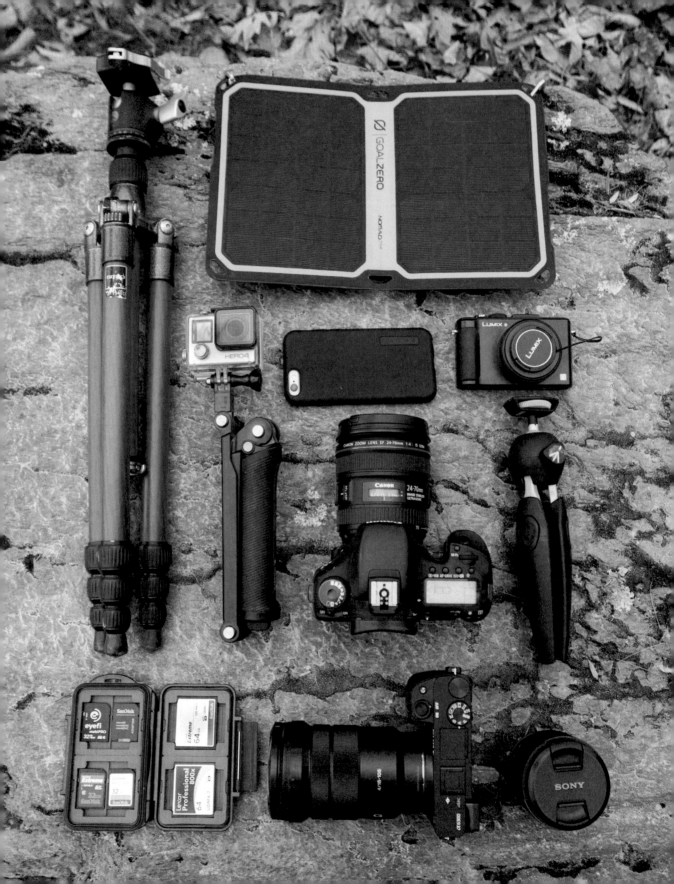

2. Choosing Camera Equipment

Purchasing camera equipment for a hiker can sometimes feel like an overwhelming task. There is a dizzying array of makes and models available and important features to consider when purchasing your equipment. With so many options, it can be difficult to know exactly which camera is best for you. Add to that the pressure of deciding how much of your beloved photography gear is worth carrying out on the trail, and you have a real challenge on your hands. This chapter is devoted to making sense of all the confusing technical jargon and helping you sort through all those difficult choices that arise when deciding what camera equipment to buy.

in this chapter:

» Typical Camera Features & Image File Types

» Common Types of Digital Photo Cameras

» Practical Accessories for Carrying, Stabilizing & Charging Cameras

Figure 56 (opposite)
Sample Camera Equipment
DSLR, f/4.5, 1/125, 16mm, ISO 400

Camera Features

Before comparing the different types of digital cameras available on the market today, it is necessary to have a good understanding of the various features and specifications that determine the individual qualities of a particular camera type and model.

Hardware

Size & Weight

From tiny, featherweight action cameras to heavy, full frame DSLR cameras, size and weight vary greatly. Generally speaking, the bigger the camera, the better the quality. Recently, mirrorless cameras have come a long way in reducing size and weight without sacrificing quality. This is definitely an important consideration for hiking photographers as weight and space are critical factors in determining what camera equipment to carry out on the trail. What you intend to do with your photos once you are off the trail should also determine what kind of camera you need.

Resolution (Megapixels)

Camera manufacturers continue to increase the number of megapixels (MP) on the sensor, but this does not necessarily improve the quality of the photograph. The more megapixels your camera has, the higher resolution your photographs will be. Unless you have a larger, full frame sensor, more megapixels do not automatically add value. For displaying photographs on digital devices, 5 MP is more than sufficient for a sharp image. For large-scale prints (11x14" or bigger), 10 MP is sufficient. The real benefit of more megapixels is the ability to crop photographs and still maintain a high-quality resolution to print on a large-scale. Keep in mind that a higher MP count can really add up in file size, filling up space on memory cards while shooting and on your computer, which affects long-term storage.

Sensor

The size of a camera's sensor ultimately determines how much light it uses to create an image. A bigger sensor is more sensitive to light and records more information. This means better quality images and better low-light performance. However, larger sensors generally also mean heavier, bulkier, and more expensive gear. Depending on the type and quality of the camera, sensor sizes can vary greatly, from 1/3" in entry-level cameras to larger crop sensors in more advanced cameras, to full frame sensors in professional-level camera bodies.

Relative Sensor Size						
Sensor Type	1/2.3" (4:3)	1/1.7" (4:3)	2/3" (4:3)	4/3" (4:3)	APS-C (2:3)	Full Frame (2:3)

Lens

Cameras feature either built-in or interchangeable lenses. The ability to change lenses gives you greater flexibility and better control over your photography, making DSLR and Mirrorless cameras superior in this category. The type of lens you need varies greatly depending on what type of photography you are doing. A telephoto lens is essential for capturing wildlife, while a wide angle lens is useful for landscapes. A macro lens is helpful for close-up subjects, such as wildflowers and insects. Hikers have to consider weight and space when selecting lenses. One option is to choose a single, high-quality zoom lens, such as a 18-105mm, that will cover most situations.

Figure 59

Comparing Lens Types (built-in vs. interchangeable)

(left) DSLR, f/3.5, 1/250, 35mm, ISO 800

(right) DSLR, f/4, 1/160, 35mm, ISO 400

Focal Length

The focal length of a lens, represented in millimeters, determines the angle of view (how much of the scene will be captured) and the magnification of the scene. Focal length has a big impact on how "close" you can get to your subject. Focal length also impacts perspective: a wide angle creates the illusion of greater separation, while a telephoto lens makes elements appear as if they were stacked closer together. Available focal lenghts range from wide angle (10-22mm), to mid-range (25-80mm), to telephoto (100-300mm) and beyond.

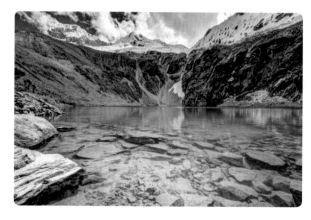

Figure 60 **Laguna 69**
Cordillera Blanca, Huascarán National Park, Peru
DSLR, f/16, 1/30, 10mm, ISO 100

Figure 61 **Chisos Mountains at Sunrise**
Big Bend National Park, TX
DSLR, f/16, 1/20, 180mm, ISO 400

Focus

Cameras feature either automatic focus (AF) or both automatic and manual focus (MF). A camera that offers both auto and manual focus gives you greater control. More advanced cameras offer a range of AF shooting mode options (continuous, single, automatic and manual) and the ability to control the selection of AF points. Automatic focus is useful for most situations, but sometimes manually adjusting the focus can produce a sharper image than the camera's autofocus mode.

Zoom

Cameras employ digital and/or optical zoom. Optical zoom is far superior to digital zoom. While optical zoom uses the optics of the lens to zoom in on a subject and enlarge it, a digital zoom enlarges to the camera's optical limit (based on the focal length of the lens) and then simulates zooming up to X times by enlarging the central portion of the photograph. This significantly decreases the overall resolution by cropping the photograph before it is taken. Be wary of cameras that offer this feature, and, if possible, look for the ability to disable digital zoom, as it is better to crop a photo in post-processing than in the camera directly.

Figure 62

Comparing Memory Card Types (mini-SD, SD, CF)

DSLR, f/8, 1/40, 26mm, ISO 800

Memory

Options include built-in memory or removable cards, including SD (Secure Digital), mini-SD, and CF (Compact Flash). Removable cards allow you to keep shooting in the field without having to back up your photos on a computer. The size of card will affect how many photos you can store on your camera. This also depends on whether you are shooting JPEGs, RAW files, or both.

Battery Life

How long a camera's battery will maintain a charge under normal conditions depends on a variety of factors, such as the quality of the battery, its maximum capacity, the type of photography (long exposures and use of flash drain faster), efficient use of camera (auto corrections and extensive LCD use drain faster), and the ambient temperature (colder temps drain faster). Know how long your batteries should last and plan accordingly for your hiking trip. Take extra batteries or a way to charge the battery in the field, such as a solar charger or a battery pack.

LCD Screen

Standard on most cameras, the size of the LCD screen as well as its resolution varies. The larger the LCD screen, the easier it is to see your photos, both while composing your shot and reviewing the results. Reflective coating can make it difficult to view screens in bright sunlight. Some screens flip up for easier viewing. Larger LCD screens consume battery power faster than smaller ones. Be aware that RAW photos are converted to JPEG for viewing on LCD screens and may appear sharper and more saturated than the actual photo.

Flash Type

Most cameras come with built-in flash. Advanced cameras will allow you to attach an external flash unit for greater control and a greater range. Advanced cameras also allow you to control the strength of the flash. Flash allows you to add light to a subject for better exposure. Built-in flash has limited range, while external flash can illuminate a subject at greater distances and from different angles than from directly behind the lens.

Water Resistance

Many cameras from smartphones to DSLRs advertise water resistance. Some cameras claim to be waterproof to a certain number of meters under water. You can improve water resistance by protecting your camera with water resistant bags and specially designed plastic cases. A waterproof casing comes standard with action cameras but must be purchased separately for all other cameras. Camera gear is expensive, and water is the enemy. Be extremely careful when shooting in the elements. Water resistance may help protect your camera gear temporarily, but exercise caution and good judgment when shooting in less-than-optimal conditions. Better safe than sorry!

Figure 63 **Waterproof Action Camera Casing** *DSLR, f/3.5, 1/125, 35mm, ISO 400*

ISO Performance

From low (24, 50, 100) to very high (6400+), ISO is an expression of the light sensitivity of your camera's sensor. The higher the ISO number, the more sensitive your camera's sensor is to capturing information in low-light situations without the aid of an additional light source like a flash. In combination with aperture and shutter speed, ISO is one of the three key variables used to correctly expose an image. Photos taken at higher ISOs introduce a grainy quality known as "noise". The least "noisy" photos are taken at the camera's base ISO (its lowest available ISO). Ultra-high ISOs are typically only available in more advanced cameras.

Aperture

Aperture refers to the opening or "eye" of the camera and controls how much light is allowed through the lens to the sensor. Expressed as the "f-stop", a lower number (f/4) indicates a wider opening that allows more light to reach the sensor, whereas a higher number (f/22) indicates a smaller opening that allows less light to reach the sensor. The maximum aperture is dependent on your choice of lens. In combination with ISO and shutter speed, aperture is one of the three key variables used to correctly expose an image. Aperture choice determines depth of field, i.e., how much of the photograph is in focus in front of and behind the subject. The ability to manually adjust aperture is critical to gaining creative control of your photography.

Shutter Speed

Shutter speed refers to the length of time the shutter is open, allowing light to hit the sensor. It is expressed in seconds (1", 5", 30") or fractions of a second (1/60", 1/250", 1/500"). In combination with ISO and aperture, shutter speed is one of the three key variables used to correctly expose an image. The choice of shutter speed can either freeze or blur motion and can be useful for handling low-light situations. The ability to manually adjust shutter speed is critical to gaining creative control of your photography.

Image Stabiliztion

Image stabilization (IS) can improve the quality of your photos by reducing shake, thereby increasing sharpness. IS helps to prevent blurry photographs by counterbalancing motion through lens-shift (in the lens), sensor-shift (in the camera body) or electronic stabilization (sharpening) technologies. For a time, lens-shift stabilization was considered superior by most, but advances in sensor-shift technologies have closed this gap in recent years. Using a camera system with sensor-shift technologies is overall a less expensive option, as it will work with every lens in your arsenal. By contrast, consumers pay extra for each and every lens they buy with IS capabilities. Electronic image stabilization is yet another means of countering shake. It is not as effective but is the only option available in compact cameras. Unfortunately, you do not get much of a choice with this feature. The brand of DSLR or type of camera you use will determine the IS system available to you.

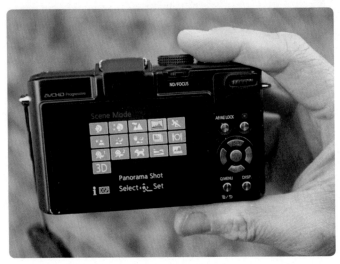

Figure 64

Preset Scenes on Compact Camera

DSLR, f/3.5, 1/160, 35mm, ISO 800

Software

Preset Scenes

On cameras offering preset scenes, the photographer identifies the photographic situation and selects the appropriate match from the list of preset scenes available (e.g., Portrait, Sports, Landscape, Night). The camera then changes the aperture and shutter speed settings automatically to best handle that type of photography. Think of this feature as "training wheels" for the beginner photographer who wants to step up their photography game. More advanced photographers will opt for using manual settings instead of preset scenes.

Metadata

Metadata refers to the information recorded about an image, such as date, GPS location, ISO, file type, lens aperture, shutter speed, focal length, and flash used. Most of the newer cameras record this information with each image you take. Metadata is useful for sorting images, organizing your photo library, referencing which camera settings were used, and learning from them to improve as a photographer.

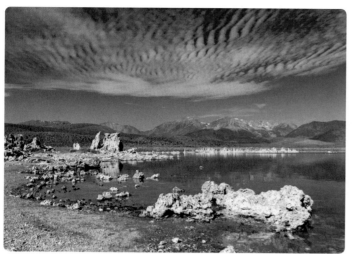

Add a Title
IMG_0290.JPG
July 28, 2016 9:17 AM

Apple iPhone 6s
iPhone 6s back camera 4.15mm f/2.2
4032 × 3024 3.4 MB JPEG

ISO 25 4.15mm 0 ev f/2.2 1/2564

Add a Description

Add a Keyword

(+) Add Faces

Mono Lake, Lee Vining, United States

Figure 65

Original Photograph and Image Metadata

Mono Lake, Tufa State Reserve, CA

Smartphone, f/2.2, 1/2564, 4.15mm, ISO 25

Self-Timer

Practically all cameras offer a self-timer feature which delays the actual photograph from being fired for a set amount of time after the shutter button is pressed. A 10-second delay is typical, but some cameras also offer a handy 2-second delay. This feature is very useful for the hiking photographer. The 10-second delay allows you to take better-composed photographs of yourself or your group than a selfie. The 2-second delay can be used to reduce shake in low-light or close-up situations and saves time over the 10-second delay. It is best to carry a tripod if you want to take advantage of this handy tool.

HDR

This setting automates the HDR process of shooting multiple exposures of a scene and combining them into a single photograph that captures the entire dynamic range of light (from shadows to highlights) in the scene. Automatic HDR is available in smartphones, compact, and action cameras. With DSLR and some mirrorless cameras, you will need to complete the HDR process manually and combine the varied exposures with post-processing software. This requires a greater skillset both in the field and at home on the computer but often leads to higher quality results.

Time Lapse

This feature allows you to capture multiple images and replay them in a faster-than-life movie. Time lapse is a built-in function on some cameras or can be done with the aid of an intervalometer and post-processing software. This is useful for creatively capturing any subject where the subtle movement over time cannot be expressed in a single photograph, such as the movement of clouds, the setting of the sun, the blooming of a flower, or the eruption of a geyser.

Figure 66

DSLR Timer Remote Controller

DSLR, f/2.8, 1/80, 23mm, ISO 1000

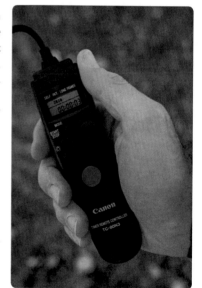

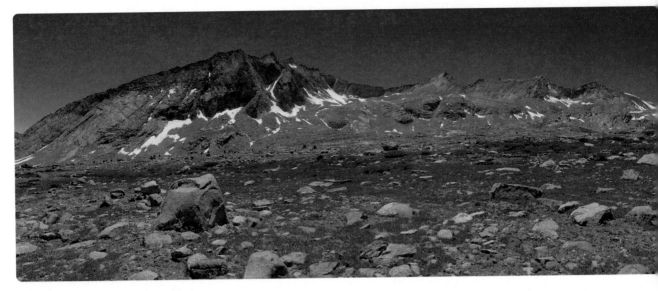

Figure 67

Approaching Mather Pass
John Muir Trail, Kings
Canyon National Park, CA
*Compact, f/8, 1/500,
4.7mm, ISO 100
(Panorama)*

Panorama

This setting allows you to capture a wider landscape image than would normally fit in a single shot by stitching together several continuously shot images as you pan across the horizon. Automatic panorama is available in smartphones, compact, and mirrorless cameras. With DSLR cameras, you will need to complete the panorama process manually and combine the multiple exposures with post-processing software. This requires a greater skillset both in the field and at home on the computer but often leads to higher quality results.

Frame Rate

How many photos per second the camera can take varies greatly depending on the quality of the camera. Generally, the better the camera, the higher the frame rate. Action cameras are an exception with a "burst mode" setting that captures as many as 30 shots in one second. Frame rate is an important feature for capturing wildlife and moving subjects as well as time-lapse photography. In order to take full advantage of a high frame rate, be sure to have a high quality memory card with a fast write speed.

Image File Types

JPEG

JPEG images are the most convenient format for the casual photographer. When a photograph is taken, the image is processed in the camera into a JPEG file that is smaller, more saturated, and sharper than the original file. JPEG files are hassle-free and are immediately available for uploading, sharing on social media platforms, and printing. This convenience comes at a price, however. When your photo is processed and compressed in the camera, some of the image data is lost forever. JPEGs typically need less post-processing than other file formats, but this is where the benefits of shooting JPEGs cease. The compressed file of a JPEG contains less information and is less forgiving in post-processing, making it more important to get the exposure correct in the camera.

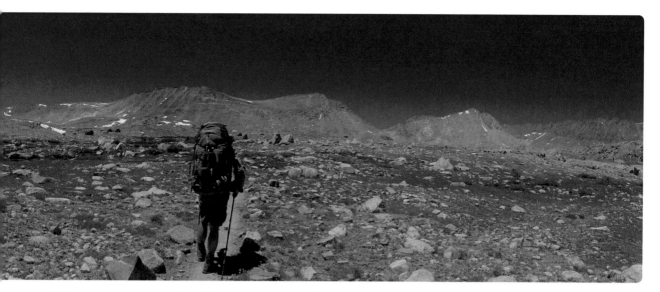

JPEGs are lossy, meaning that all further edits, including merely the act of opening and saving, made on a JPEG file result in further information loss. These trade-offs may be worthwhile when taking large numbers of photos or when highest quality is not the top priority.

RAW

RAW files are proprietary to the camera manufacturer, but they all share similar characteristics. RAW files contain all of the information recorded by the camera's sensor when the photograph is taken. Special software is required to convert RAW files into an image that can be shared and printed. While RAW files typically look flatter, duller, and less sharp than their JPEG counterparts, images shot in RAW allow more flexibility in post-processing. The uncompressed files contain far more information that can be used to optimize your images. More information means more flexibility, and many technical deficiencies that occur during exposure can be corrected during post-processing. RAW files are lossless and can be edited, opened, and saved without losing information. RAW files are roughly 2-3 times larger than JPEGs, filling up memory cards and hard drive space faster, but, when maximum quality is the goal, RAW is definitely the way to go.

In order to overcome the limitations of proprietary RAW formats, Adobe created the open standard DNG (Digital Negative), which is compatible with many major software products. However, there is an ongoing debate over whether or not to convert your RAW files to DNG, so be sure to conduct your own research and weigh the pros and cons carefully.

TIFF

The TIFF file format is far less common than JPEG or RAW and is offered by fewer camera manufacturers. TIFF files share many of the benefits of RAW files and can be opened directly by some editing software programs. The TIFF format is also lossless and is considered the best format for printing. While the quality of TIFF files is on par with RAW files, they are not as popular because TIFF files are extremely large, making them impractical for most photographers.

Types of Cameras

There are more types of cameras available than ever before for the hiking photographer to document his or her time out on the trail. From convenient smartphones to compact point-and-shoots, from lightweight mirrorless cameras to high-quality DSLRs, and even miniature action cameras capable of taking surprisingly good photos and video, there is a plethora of options to choose from. Each type of camera has its own set of unique characteristics, making it the "perfect" choice depending on the particular subject or situation, the type of hiking trip, and the ultimate purpose of your photography.

Smartphones

Figure 68

Photographing Windows Arch with a Smartphone

The Windows Trail, Arches National Park, UT

DSLR, f/22, 1/15, 26mm, ISO 100

For size, weight, and convenience, it is hard to beat a smartphone. With its slim design and modest weight (typically under half a pound), a smartphone can be carried in almost any pocket, making it super accessible. Its large LCD screen is satisfying for composing and reviewing photographs and videos, and additional features like automatic HDR, panorama, and time-lapse add to its appeal. Lens kits including wide angle, telephoto, and macro are available for supplementing the built-in fixed focal length lens. Many post-processing apps are available for optimizing photos right on your phone without going through the hassle of transferring images to a computer. There is no quicker or easier way to share photos via email or social media sites than with a smartphone. It is the perfect camera for the casual photographer or the long-distance backpacker who values weight and convenience over quality.

Despite all those benefits, it is difficult to recommend using a smartphone as your primary camera if you are serious about your photography. While a smartphone's small sensor helps keep its size and weight at a minimum, the resulting images are only suitable for digital display or small-scale prints at best, no matter how many megapixels manufacturers manage to squeeze into them. Its miniature lens lets in little light and is best for shooting in the bright light situations that serious nature photographers hope to avoid. Smartphones have a built-in fixed lens that is adequate for taking landscapes and scenics but requires shooting at close range for other subjects – not usually an option for capturing wildlife encountered on the trail.

With no optical zoom, smartphones are limited to using a digital zoom, which results in an unappealing grainy image. Many current smartphones do not offer the ability to set ISO, aperture, or shutter speed, and, while that large LCD screen is beautiful, it is also power hungry and drains the phone's battery quickly. Smartphones have limited storage capacity. Once the built-in memory is full, your only options are to transfer photos to the cloud or a computer. This could be an issue for trigger-happy photographers or those going on longer, more remote backpacking trips.

Compact Cameras

As their name suggests, compact cameras are another small and lightweight option for the hiking photographer. Weighing under a pound on average and small enough to comfortably wear on a hipbelt, compact cameras offer a noticeable upgrade in quality and performance from a smartphone without a significant increase in size or weight. Currently, the best compact cameras on the market contain a sensor up to 1" in size with enough megapixels to allow printing of up to 8x10" prints at excellent quality and even 11x14" prints at good quality. Known as point-and-shoot cameras for their ease of use, many higher quality compact cameras also offer manual controls, allowing the photographer to set important functions like ISO, aperture, and shutter speed (although many of these features are a result of a mathematical algorithm performed within the camera rather than an actual physical adjustment).

Compact cameras typically can shoot video and offer many preset scene options, such as HDR, panorama, night sky, sports, portrait, and flower mode, to help beginning photographers get the appropriate camera settings for common scenarios. Built-in zoom lenses on compact cameras offer far greater focal length than smartphones, but many models make use of a digital zoom that is inferior to an optical zoom. LCD screens on compact cameras are typically smaller than on smartphones, but this results in longer battery life. Most compact cameras use rechargeable batteries and record images on removable SD cards, allowing more flexibility when heading into the wilderness for longer trips.

Newer compact cameras come with built-in WiFi, allowing users to transfer JPEG images shot on their camera directly to their smartphones for editing, sharing, and posting to various social media platforms. Compact cameras also tend to be far more affordable than mirrorless or DSLR cameras. Compact cameras make a great option when size, weight, and accessibility are a primary concern, but they still leave a lot to be desired if creative control and quality are your top priority.

Figure 69

Photographing Fall Colors with a Compact Camera
Spivey Gap, Appalachian Trail, Pisgah National Forest, NC
DSLR, f/6.3, 1/25, 26mm, ISO 800

Action Cameras

Action cameras have become extremely popular with hiking photographers in recent years, as they have a unique set of features that makes them stand out from the other cameras that you may consider bringing along on the trail. At under half a pound, these tiny, featherweight cameras are barely bigger than a postage stamp and can fit most anywhere, though they are designed to be attached to the user rather than buried in a pocket or pouch. A rugged and waterproof housing can be used with a variety of mounts (purchased separately) to give the photographer the ability to attach the camera to almost anything, including backpack straps, head harnesses, and sternum straps, and capture the hiking experience from a unique point of view under any condition, rain or shine. Action cameras utilize a fixed, extreme wide angle lens that is well-suited to capturing "selfie" photographs and videos of the user out on the

trail but can also be used for creative photography. The extreme wide angle can be used to show off strong foreground subjects along with their surroundings, take photographs in tight spaces that would be otherwise impossible, and even capture the night sky. The quality of the video and photo shot by action cameras is surprisingly good given their diminutive size. Burst mode, a self-timer, time-lapse options, and the ability to control the camera with a smartphone are additional features that many hiking photographers will enjoy.

One of the ways in which action cameras keep their size to a minimum is by limiting the amount of bells and whistles. Operation is controlled by just a few buttons, and the miniscule LCD screen is barely adequate for composing shots, although the lens is so wide that it manages to capture almost everything in front of it. Images and videos are recorded onto mini-SD cards, and spare batteries weigh approximately 1 ounce. This is a good thing, because action cameras run through batteries quickly. You will certainly need to carry many of them if you wish to document your trip thoroughly.

While this is a fun camera to have in the arsenal, it has definite drawbacks that should be weighed before considering using it as your primary camera. An extreme wide angle lens has limited versatility and works best when including a strong foreground subject in the scene, like a hiker on the trail or a flower on a mountain pass. It can also result in a distorted and unflattering image, especially when people are not centered in the image. With no ability to zoom or change lenses, action cameras do a poor job of capturing big landscapes, wildlife, or many other scenarios you will want to document. Action cameras are best-suited for the aspiring documentarian who wants to capture the action of being on the trail in a creative and hands-free way.

>> *Be aware that the operation of unmanned aircraft systems (which includes drones) is prohibited in U.S. National Parks and designated wilderness areas on National Forest System lands.*

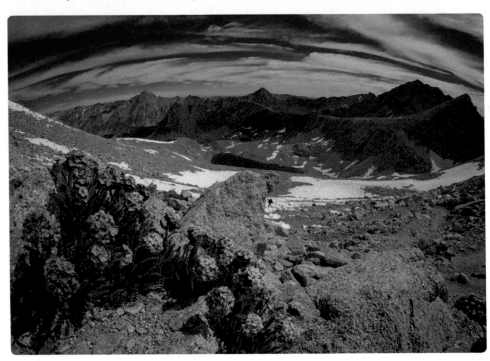

Figure 71

Sky Pilots near Forester Pass

John Muir Trail, Kings Canyon National Park, CA

Action, f/2.8, 1/2700, 3mm, ISO 100

DSLR Cameras

Digital Single Lens Reflex (DSLR) cameras have been the weapon of choice for serious camera enthusiasts and professional photographers alike since they arrived on the market. DSLR cameras have the largest sensors available, ranging in size from APS-C to full frame. With all that valuable sensor space, there is plenty of room for megapixels, resulting in high resolution images with magnificent detail that can be printed at sizes of 16x20" and larger. The larger sensor also allows you to crop images and still maintain a high enough resolution for larger prints and digital display. For full creative control of your photography, nothing quite compares to the features and settings of a DSLR. Interchangeable lenses at every conceivable focal length are available to shoot any subject you may encounter while in the field. High ISO settings combined with a larger sensor help to capture stunning photographs during sunrise, sunset, and Golden and Blue Hours when other cameras really struggle to perform. Fast shutter speeds, high frame rates, and a variety of focusing modes help ensure that you capture subjects on the move.

Figure 72

Photographing in the Rain with a DSLR

Chicago Basin Trail, Weminuche Wilderness, CO

Compact, f/8, 1/200, 7.9mm, ISO 400

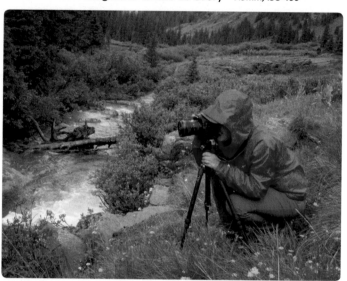

Using the viewfinder (rare in other cameras) to compose shots helps keep battery consumption down. The option to manually focus in Live View using the LCD screen is a luxury that simply cannot be beat when sharp focus is a top priority. A hot shoe for attaching external flash units and the ability to plug in a remote trigger release are additional features that can help raise your outdoor photography to the next level. And, if you are hoping to get creative and capture the beauty of night skies with star trails, the Bulb feature available on DSLRs gives the ability to open the shutter for an extended period of time, a feature totally unavailable on smartphones, compact, and action cameras.

All of the high-quality performance of a DSLR camera comes at a serious price, however. DSLR cameras are by far the heaviest and bulkiest cameras on the market. While the plastic bodies of entry-level DSLRs are lighter and more compact (around one pound), the higher quality models are made of metal which significantly increases their ruggedness and weight. With regard to photography, nothing quite compares to the satisfaction of shooting with a solid chunk of metal in your hands, but your back and feet may beg to differ after lugging a cumbersome DSLR around for all those long miles on the trail. The size and weight of a DSLR make it most comfortable to carry stored away inside a backpack when covering longer distances. This lack of accessibility is a serious detriment when timing is critical or when fatigue becomes a factor in your photography.

DSLR cameras are also far more expensive than their smaller counterparts, and, while having multiple lens options is a great feature, additional glass is pricey, heavy, and bulky, too. A DSLR camera does not offer the preset shooting scenarios that smartphones and compact cameras do, requiring users to have a greater knowledge base and skill set to get the most

out of their cameras. The primary benefit of using a DSLR, of course, is the potential for professional-quality, detailed images that can be printed on a large scale, but, if that is not your main goal and purpose, a DSLR may be more camera than is necessary.

Mirrorless Cameras

So, if you are thinking your options come down to a choice between size/weight or quality, do not give up hope just yet. Consider going mirrorless, and you can enjoy the benefits of a DSLR camera in a more compact and lighter design. Mirrorless camera systems first appeared on the market less than a decade ago, and, while considered a novelty at first, they have rapidly started giving DSLR cameras a serious run for their money, particularly among the backpacking community. DSLR cameras use a mirror to reflect what is seen through the lens into a viewfinder. As its name suggests, the mirrorless camera does not use a mirror. Instead, the lens is mounted directly in front of the sensor, and the information is relayed directly to

the LCD screen. This results in a slimmer and smaller camera that is a fantastic option for the hiking photographer who wants high-quality images without the heavy weight of a DSLR. Even with a zoom lens, mirrorless cameras are light enough to be carried comfortably outside the pack using a clip or harness system that allows this powerful camera to be kept right at your fingertips when out on the trail.

With image quality and advanced camera features roughly on par, there are a few significant differences between mirrorless and DSLR cameras that should be mentioned. Mirrorless cameras employ an electronic viewfinder in place of the

Figure 73

Photographing Fall Colors with a Mirrorless Camera

Spivey Gap, Appalachian Trail, Pisgah National Forest, NC

Compact, f/8, 1/10, 10.8mm, ISO 400

optical viewfinder found in a DSLR, which is definitely not as sharp or as satisfying to look through when composing shots. Mirrorless cameras rely heavily on their power-hungry LCD screens, much more so than their DSLR counterparts. This drains the camera's batteries rapidly and can become somewhat restrictive in the field, especially on longer hiking trips.

Mirrorless cameras maintain their sleeker design by eliminating many of the exterior buttons and switches found on DSLRs that are used to adjust camera settings. Instead, these features are controlled and set within digital menus, which takes more time to access than simply rotating a dial, so you should expect a learning curve when first getting to know this camera. Mirrorless cameras are also quite expensive. Most mirrorless bodies are over $1000 with additional lenses costing several hundred dollars apiece. As a relative newcomer in the photography field, mirrorless camera systems are not as fully developed as DSLRs, nor is the lineup of lenses as extensive. Mirrorless cameras come in both crop and full frame sensors, but it should be noted that the lenses for full frame mirrorless cameras are quite large and heavy, negating most of the advantages of going mirrorless. Even so, the current quality versus size/weight is remarkable for mirrorless cameras, making them an excellent choice for hiking photographers with high standards who are conscious about camera weight.

Our Take

Deciding which camera and equipment to bring out in the field is always a difficult decision for us, and the answer usually depends, first and foremost, on how long we will be out on the trail. On day trips and supported treks where we only need to have a daypack, we are each comfortable carrying a DSLR camera, usually with a change of lens that is chosen depending on what we are most likely to see out there. We are less likely to bring an action or compact camera on day hikes as we are hoping that the shorter trail time will afford us more quality photography time.

On longer backpacking trips where weight becomes a more significant factor, we usually bring a compact camera that can be carried on a hip belt and accessed quickly and easily for taking images along the trail that mostly serve to help tell the story of our experience for our blog. We typically only bring one DSLR camera, perhaps with an extra lens, to share between us. At nearly 5 pounds, we work hard to justify this weight and try to time stops and breaks at places that inspire us to unearth the camera from our backpacks. We always carry a lightweight tripod as well, so that we can use our DSLR during Golden and Blue Hours, at sunrise and sunset, and for nighttime photography. Occasionally, we document our longer trips on video as well for sharing on our blog, so we also bring an action camera for this purpose. We recently acquired our first mirrorless camera and love the quality and accessibility it offers in such a lightweight package. We consider it a game changer for our trail photography, and soon it may replace all of our other cameras. Time will tell.

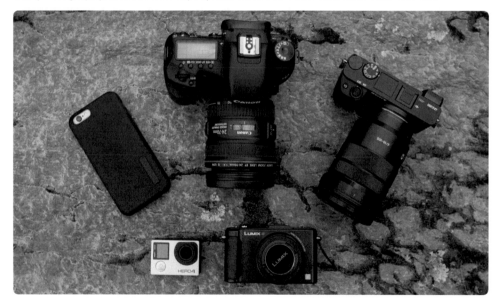

Figure 74
Overview of Different Camera Types
DSLR, f/4.5, 1/80, 22mm, ISO 400

Purchasing a New Camera?

Camera technology is constantly improving, and manufacturers are doing their best to pack as many new features as possible into the latest models for every type of camera. Even so, there are a few key features that hiking photographers should pay particular attention to when considering the purchase of a new camera. Take the time to do some research on the specific camera models you are interested in buying.

As a starting point, use the selection criteria below in combination with the details provided in Table 1 to narrow down the options that best meet your personal goals and requirements.

- **Image Quality:** Larger sensors and higher resolutions allow large-scale printing and cropping. Smaller sensors and lower resolutions are best suited for social sharing and digital display.

- **Variety of Subjects:** Interchangeable lenses and/or optical zoom are ideal for frame-filling flower, wildlife, and landscape shots. A built-in lens with fixed focal length works best for general photography.

- **Exposure Control:** Manual settings provide more control over a wider range of light conditions (e.g., Golden Hour, Blue Hour, and at night). Automatic settings provide limited control over exposure and work best in daytime conditions.

- **Built-in Options:** Preset scenes and ready-to-use shooting modes offer easy shooting options but less creative control of images.

- **Weight and Space:** Lightweight, slim designs are suitable for any type of trip. Heavy, bulky designs may be best for shorter outings and day-hikes.

- **Cost:** Entry-level cameras and accessories typically cost less, while advanced-level equipment can be expensive.

Feature	Smartphone	Compact	Action	Mirrorless	DSLR
Sensor Size	small (1/3" - 1/1.2")	medium (1/2.3" - 1")	small (1/3" - 1/2.3")	medium/large (1/2.3" - Full Frame)	large (APS-C - Full Frame)
Megapixels	up to 16	up to 20	up to 16	up to 24	up to 36
Focus	AF	AF/MF	AF	AF/MF	AF/MF
Lens	built-in*	built-in	built-in*	interchangeable	interchangeable
Focal Length	fixed*	limited range	fixed*	wide range	wide range
Zoom	digital	optical/digital	n/a	optical	optical
ISO, Aperture, Shutter Speed	limited range & control (if any)	wider range & control	fixed/automatic	widest range & control	widest range & control
Flash Type	built-in	built-in	n/a	built-in/ dedicated	built-in/ dedicated
Preset Scenes	yes	yes	no	yes	no
HDR	automatic	automatic	automatic	automatic	manual only
Panorama	automatic	automatic	n/a	automatic	manual only
Weight	3-7 oz.	7-11 oz.	2-5 oz.	0.5-1 lb.	1-2 lbs.
Price Range	$300-700	$300-600	$200-500	$400-1,500	$500-4,000

Table 1

Comparison of Common Camera Types and Features

* add-on lens kits available

Please note, the technical specifications provided above reflect what is available on the market at the time of writing this book. Given the rapid pace at which technology advances, you are well-advised to conduct your own online research for more specific details on current camera types and models before making a purchase.

Accessories

Wouldn't it be nice if all the choices you had to make about your camera gear stopped with the camera? Picking the right camera is just the start. The hiking photographer must choose from an abundance of camera accessories to carry, power, stabilize, and protect their camera, too. No matter what type of hiking trip you are on, you will need additional gear to document your journey.

Carrying Your Camera Gear

First and foremost, it is important to think about how you are going to transport your camera while on the trail. Accessibility is the key here, and finding a system that allows you to carry your camera comfortably while still allowing quick access to your gear is essential. A wide variety of cases, harnesses, backpacks, and clips are available for transporting your equipment. What you choose will likely depend on what type of camera you are carrying and your own personal preferences.

Smaller cameras like smartphones, compact, and action cameras can easily be stowed in small padded cases that attach to your hip belt or even a sternum strap. These can be purchased as aftermarket items at camera or outdoor gear stores. Many backpacks on the market these days feature hip belt pockets, so, depending on the size of your camera, an additional case may not even be necessary.

Larger DSLR and mirrorless cameras require a little more thought and creativity. Backpacks, of course, are the easiest and most comfortable way to carry camera gear. Most hikers are already using a backpack to carry everything else needed on the trail, like food, water, and rain gear. So, why not use it for your camera, too? Stowing your camera gear in a backpack is really inconvenient. Who wants to stop, take off their pack, and dig out their camera gear every time they want to take a picture? Trust us

Figure 75

Hiking Photography Backpack

DSLR, f/6.3, 1/160, 23mm, ISO 400

when we say this gets old quickly, and, before long, most hikers miss photographs when timing is essential to getting the shot. Worse yet, they start weighing whether or not the photo opportunity is worth the effort to get the camera out at all and decide they cannot be bothered. Why go through the effort of carrying a heavy camera out on the trail if you are not going to use it?

A variety of products is currently available for making the prospect of carrying DSLR or mirrorless cameras much easier. After countless miles on the trail, we have found the following products to be particularly useful.

Rotation Backpacks

These innovative backpacks are split into two separate compartments: An upper compartment for storing rain gear, extra layers, food, and other hiking essentials, and a lower compartment for heavier camera gear in a slidable waistpack. The lower compartment comes with removable dividers that allow you to customize the pack to fit whatever camera and lenses you wish to take out on the trail.

The primary benefit of the rotation backpack is that it allows efficient access to camera gear without having to take the pack off. Whenever an opportunity presents itself, simply loosen the waist belt, unclip the side panel, and slide the waistpack 180 degrees to access the camera gear. With a quick zip, the camera, lenses, and filters are immediately available for use.

After capturing the shot, all gear can be stowed away just as quickly, getting you right back on the trail. We use rotation backpacks on day hikes and on longer supported treks where we do not have to carry our tent, sleeping bag, and food. We love how this system keeps our heavier camera gear low on our hips where it belongs and allows us to document our experience without sacrificing too much time. Additionally, rotation backpacks help us to conserve energy, since we are not constantly taking our packs off to access our cameras. Popular manufacturers: MindShift

Top-Loader Holster-Style Bags

These padded bags offer decent protection for your camera. Straps can be configured for the bag to be worn as a chest harness, keeping the camera in front of your body to provide easy access to your gear while hiking. Bags large enough for DSLR or mirrorless cameras can be quite bulky, though, and some may find wearing a large bag against the chest hot and cumbersome while hiking. Popular manufacturers: LowePro

Harness Systems

Many manufacturers make hands-free harness systems that utilize a back strap and clips to carry only the camera (without its case) next to the hiker's chest. Having the camera easily accessible is a major benefit, but the lack of any protection from rain and dust may be a turnoff for some. Popular manufacturers: Cotton Carriers, ThinkTank

Capture Clip

This innovative system utilizes a sturdy aluminum clip that can be attached to the shoulder strap or hipbelt of a backpack. A separate plate screws into the base of the camera, allowing the camera to be quickly and easily locked into and released from the clip with the click of a button. The capture clip holds the camera rigidly in place, preventing any bouncing while hiking, and a handy neoprene shell can be purchased separately to protect against dust and rain. The plate is also compatible with many popular styles of ballheads, making it convenient to use when shooting from a tripod. We backpacked around Washington State with a capture clip and absolutely loved the superfast accessibility it gave us to our mirrorless camera. Popular manufacturers: PeakDesign

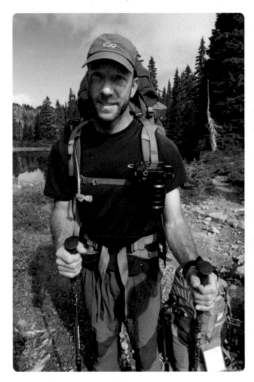

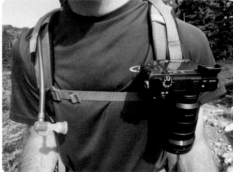

Figure 77

Camera Capture Clip
Compact, f/8, 4.7mm, ISO 200,
(left) 1/400,
(top right) 1/200,
(bottom right) 1/320

Battery Packs & Solar Chargers

Keeping camera batteries charged while in the field can quickly become a concern for the hiking photographer. This depends on several factors, including the type of camera, the amount of images taken, LCD screen usage, outdoor temperatures, and the length of your trip. Smartphones, action cameras, and mirrorless cameras drain batteries quickly. It is not uncommon to use an entire battery over the course of a well-documented day on the trail. If possible, turn off your camera's LCD screen to prevent unnecessary battery usage. Be aware that shooting in cold temperatures will drain your batteries more quickly. Keep batteries warm by sleeping with them in your sleeping bag on cold nights and by tucking spare batteries into an interior pocket of your jacket during cold shooting conditions.

On longer trips, when running out of battery power is a concern, consider bringing a solar charger and/or a battery pack to recharge your camera batteries. This system works easiest with smartphones, action cameras and newer compact and mirrorless cameras that can charge batteries via the camera's USB port. Other cameras may require a separate USB charger to take advantage of solar energy.

Figure 78

Using a Solar Charger
Northern Loop Trail,
Mount Rainier NP, WA
*(left) Compact, f/8, 1/400,
4.7mm, ISO 100,*
*(right) Compact, f/5.6,
1/500, 4.7mm, ISO 100*

Solar chargers need direct sunlight to produce power. Simply set the charger out in the sunlight in camp or attach it to the top of your backpack while on the trail to collect the sun's energy. Some solar chargers come with an integrated battery that is capable of storing energy collected throughout the day, while others can only charge batteries when the device is plugged in directly. In the latter scenario, it may be helpful to carry a separate battery pack that can be plugged in for charging during the day while you are hiking. The battery pack can then be used on cloudy days or after dark in camp to top off camera batteries or other devices that require charging. Popular manufacturers: GoalZero, SunTactics, Anker, Instapark

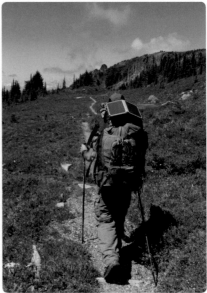

Tripods and Selfie Sticks

A tripod is an essential item for the hiking photographer who wants to improve the overall quality of their images. There are many reasons to bring a tripod on the trail. Tripods allow you to stabilize your camera and eliminate shake to achieve maximum sharpness. They also enable you to slow your shutter speed to blur motion (great for silky waterfall photographs), shoot for HDR, take self-portraits, shoot in low-light conditions, and attempt nighttime and time-lapse photography. Despite all of these benefits, the vast majority of hikers choose not to carry a tripod out on the trail with them. Why? Because tripods are heavy to carry, bulky to pack, and cumbersome to use. If that is not enough to turn you off, then maybe the price tag will, as high quality tripods can be quite expensive. Still, there are a few solutions available that can strike the balance between the need for stabilization and the desire to be lightweight and mobile.

Carbon-Fiber Travel Tripods

Lightweight and compact carbon-fiber travel tripods are our preferred choice. Smaller than their full-sized cousins, these sturdy tripods can safely support a heavy DSLR camera and still extend to a height of approximately 4 feet, more than adequate for most situations. Weighing as little as 3 pounds (with a ballhead attached), lightweight travel tripods quickly extend and collapse for quick use on the trail. They can be attached to the outside of your pack for easy access. Some models are designed to allow you to fold out the legs and remove the center column to get the camera close to the ground. This can be useful for changing your perspective and getting the camera on level with low-lying subjects, like flowers, mushrooms, and little critters. This is also helpful for night sky photography when you want to feature a foreground subject but still leave plenty of room for the starry sky. The downside of carbon-fiber tripods is the hefty price tag that comes along with the extra weight in your pack. Popular manufacturers: Gitzo, Manfrotto, Bogen, Benro, Vanguard

Figure 79

Carbon-Fiber Tripod
Appalachian Trail, Pisgah National Forest, NC
Compact, f/5.6, 1/100, 4.7mm, ISO 400

Flat-Plate Tripods

Another option for the hiking photographer who wants to save space and still achieve stability is to use a flat-plate tripod. This innovative tripod system actually has no legs at all. Instead, you attach your camera and ballhead to a lightweight aluminum plate that weighs less than a pound and is barely bigger than a smartphone. The advantage is that it is thin, compact, and easily stowed but can still support a DSLR camera with a heavy telephoto lens. It can be placed at ground level or on rocks, logs, and bridge railings. Small screws enable you to adjust the plate for uneven surfaces. It can also be strapped to trees or other objects in order to gain height. Popular manufacturers: Platypod

Flexible-Arm Tripods

If a travel tripod does not work for you, there are several other options available to stabilize your camera out on the trail. Flexible-arm tripods are smaller and lighter than traditional tripods, and they can be quite versatile. Larger models can even support the weight of heavier cameras, but, if using a DSLR, be sure to check the tripod specifications against the weight of your camera. The legs of flexible-arm tripods do not extend, but they can bend and adjust to accommodate uneven surfaces. They can even be wrapped around tree branches and bridge railings to make up for their lack of height. Flexible-arm tripods are not ultralight, but they are a less expensive alternative to a traditional tripod. Mini-tripods are even smaller, lighter, and less expensive. These can stabilize lighter compact and action cameras, but they only extend to a maximum height of less than one foot off the ground, which we find to be extremely limiting for composing shots. Mini-tripods need to be set up on a fairly even surface. This can be difficult to find on the trail, especially if you are trying to manufacture height by placing your tripod on a rock or a log. Popular manufacturers: GorillaPod, Novoflex, Manfrotto, Sirui, ProMaster

Figure 80 **Flexible-Arm Tripod** Mission Trails Regional Park, CA *DSLR, f/8, 1/125, 55mm, ISO 100*

Selfie Stick

Selfie sticks offer solo hikers a convenient and lightweight method for taking self-portraits. Selfie sticks are useful when there is no one else around to take your photo or when you want to include everyone in your group, even the photographer, in the image. Best for lightweight smartphones and action cameras, a selfie stick "extends" your arm and gets the camera farther away from you. The extra distance enables a wider point of view, allowing you to capture more of the scenery in the background or to include more people in your photograph. You can also use it to change perspective and easily shoot from up high or down low. Selfie sticks are small, lightweight, and quick to use. Hikers who are really weight conscious may opt for a hiking pole selfie adaptor. Weighing in at under an ounce, this ingenious little gadget screws into the bottom of your compact camera and attaches to the end of most trekking poles to turn them into selfie sticks. Keep in mind that a selfie stick does not offer stability and is not a replacement for a tripod. Popular manufacturers: Newisland, Urpower, Manfrotto, GoPro, GossamerGear

Filters/Lens Kits

Lens filters are available for use with cameras that have interchangeable lenses. Filters affect light entering your lens similar to the way a pair of sunglasses affects light entering your eyes. Filters attach to the end of your lens by screwing directly onto the threads found there or by being mounted into a holder that is screwed to the threads of your lens. There are many types of lens filters available, and using the appropriate one can benefit your photography in many different situations. Hiking photographers may find the following filters to be useful while on the trail.

Figure 81

Lens Filter Kit
DSLR, f/5.6, 1/320, 26mm, ISO 400

UV Haze Filter

A basic UV haze filter is a clear glass filter that is primarily meant to serve as inexpensive dust and scratch protection for your lens. An accidental scratch would damage the filter instead of the actual glass of your lens. Some photographers swear by these, while others dislike the idea of mounting inferior-quality glass in front of their expensive lenses for protection reasons only. Popular Manufacturers: Tiffen, Hoya, Nikon, B+W

Circular Polarizing Filter

A circular polarizing filter is very useful for landscape photography. This filter blocks out polarized light, producing several benefits. Circular polarizers can be used to reduce reflections off of water. This is useful for cutting glare off of surfaces, such as shiny wet rocks and leaves, when shooting streams, waterfalls, and lakes. A circular polarizer also can be

used if you want to feature what is below the surface of water, such as the stones in a stream bed or a colorful fall leaf, for example. In general, you can count on a circular polarizer to improve contrast and add vibrancy to colors in your photographs. This is useful especially when shooting during the midday when colors are more washed out and skies appear hazy. Using a polarizer can crisp up the edges of clouds and mountains and make skies appear more blue.

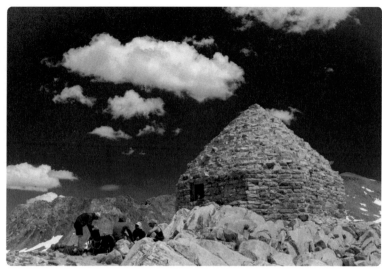

The strength of a circular polarizer is adjustable. You control the intensity of its effect by rotating the filter to your liking, but be careful not to over-polarize and make the sky appear unnaturally blue. Be aware that polarizing can eliminate the reflection off a lake's surface which may be something you intended to show. It is also important to note that you "lose light" when using a polarizing filter. The filter blocks light coming through the lens and slows down your exposures by up to one stop of light, so you may have to adjust your ISO or aperture to compensate for this. We consider a circular polarizer an essential accessory. Popular Manufacturers: Tiffen, Hoya, Nikon, B+W

Figure 82

Muir Hut at Muir Pass
John Muir Trail, Kings Canyon National Park, CA
DSLR, f/16, 1/30, 26mm, ISO 100

Figure 83

Holmafoss
Asbyrgi-Dettifoss Hike, Iceland
DSLR, f/29, 2s, 38mm, ISO 100

Neutral Density Filter

Neutral density filters uniformly block out sunlight and come in different strengths (.3, .6, .9, etc.). These filters are especially useful for shooting waterfalls and streams when you deliberately want to slow down your shutter speed to create an attractive blurred water effect. That type of image can be difficult to achieve when shooting in bright conditions or when the water is not moving fast enough to simply adjust the ISO and aperture to get a sufficiently slow shutter speed for the desired effect. Using a neutral density filter can help by blocking the amount of light coming into your lens, which, in turn, enables you to slow down your shutter speed sufficiently to produce a silky look in the waterfall. Neutral density filters can be stacked together to block out more light if necessary. We carry a set of neutral density filters in different strengths whenever we are hiking in waterfall country. Popular Manufacturers: Tiffen, Hoya, Lee, B+W

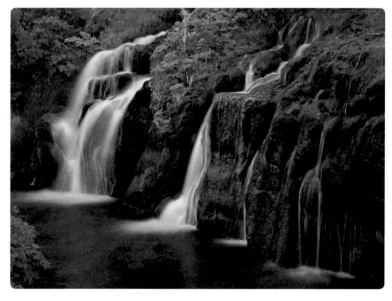

Close-Up Filter

Why carry a separate macro lens for close-up photographs of flowers and other flora when you can simply use a close-up filter instead? Close-up filters, also known as diopters, are a lightweight and affordable solution for macro photography. Unless macro photography is your primary goal while hiking, it may be a wiser use of weight and space in your pack to carry a set of close-up filters. These filters act like a magnifying glass on the front of your lens and allow your camera to get closer to small subjects to fill the frame with their interesting details. They come in varying strengths (+1, +2, +4) and can be stacked together to intensify their effect. Users should be aware that the quality of close-up filters is not on par with a true macro lens. Popular Manufacturers: Hoya, B+W, Cokin, Schneider

Step-Up Rings

Filters are sold as accessories to your lens and come in various diameters to match each lens. Unless all of your lenses have the same diameter, you will have to purchase a separate filter for each of them, which can be quite expensive. Step-up rings offer a cost-effective solution to this. Acting as adapters, they make it possible to attach a larger diameter filter to a smaller diameter lens. We find it more convenient for each lens to have its own dedicated filter. Changing filters in the field can be time consuming and exposes your lens surface to dust.

Add-On Lens Kits

Lens kits are available for smartphones and action cameras to enhance their photographic capabilities. Depending on the brand of phone/camera and lens kit, these may either clip on or thread onto your device's lens. Lens kits are available to simulate wide angle, macro, telephoto, and even fish eye lenses. Size, weight, quality, and, of course, price vary by manufacturer, so research before buying. If your smartphone is your only camera on the trail and you want to improve your photography, lens kits may provide an effective way to take your images to the next level. Popular manufacturers: Photojojo, Phocus, Olloclip, iPro

Figure 84

Padded Compartments in Rotation-Style Backpack

DSLR, f/10, 1/60, 12mm, ISO 400

Additional Accessories for Protecting Your Gear

A camera is an expensive investment, so it is important to protect it from both impact and the elements while you are on the trail to prevent damages.

Padded Storage

When your camera is stowed in your backpack, be sure to keep it protected from impact by using padded storage. If you are using a smartphone or compact camera, this may be the same case that you use for carrying your camera while on the trail. Other cameras may require a bag or case in addition to the system you are using to transport it. Padded bags for DSLR cameras tend to be bulky and difficult to fit into a backpack, but lightweight neoprene shells can offer some protection while saving on space and weight. Backpacks specifically designed for hiking photographers, like the rotation-

style backpacks mentioned above, have padded interior compartments for your camera gear and do not require any additional equipment. Popular manufacturers: LowePro, MindShift, Osprey, Think Tank, Peak Design, MegaGear

Wet Conditions

You also need to have a method for keeping your equipment dry when the weather turns wet. Water can ruin the sensitive electronics of your camera, so you must protect it from rain, snow, and other wet conditions, including when you are making challenging river crossings. There are many waterproof cases and sleeves on the market for smartphones, and even a simple zip lock bag can offer decent protection from light rain. The rigid, waterproof case for action cameras offers both impact and water protection. Similar hard cases are made for many compact, DSLR, and mirrorless cameras, but their size and weight make them impractical to carry and offer more protection than is generally necessary on a hiking trip.

Having a waterproof stuff sack large enough to quickly put your camera into will do the trick in most circumstances. You can then place your camera inside your backpack and use any additional protection, like a pack cover, waterproof liner, or even a trash bag, to protect your gear. Of course, this makes your gear more or less inaccessible during the inclement weather, when there are still plenty of good photographs to be had. Rain sleeves are specifically designed to fit around the camera body and lens and allow you to shoot in the rain. Some hikers attach small, sturdy hiking umbrellas to their backpacks, so they stay dry and can hike hands-free in the rain. Using an umbrella can also allow you to keep shooting during rain. Popular manufacturers: JOTO, Sea to Summit, Outdoor Research, Granite Gear, REI, Think Tank, Op/Tech, AquaTech, Gossamer Gear (umbrella)

Figure 85
Waterproof Stuff Sack
DSLR, f/8, 1/15, 20mm, ISO 800

Dry Conditions

Dry trails can also be a problem for your camera equipment. Dust is kicked up easily by wind and by hikers walking along dusty trails. Dust manages to get into every nook and cranny of your camera and can cause you to spend a lot of time behind the computer in post-processing doing spot removal. When conditions are really dusty, seal your camera in the same lightweight bag you use for water protection. Avoid setting your camera in the dirt. Keep your lens cap on when not shooting. Remember to look at the lens surface before shooting to see if it needs any cleaning and use a soft, dry cloth to gently clean it if necessary. Any time you open your camera to change the lens, you increase the possibility of getting dust on your camera sensor. This can result in spots that appear in the exact same place on every one of your photographs. Avoid changing lenses under windy conditions. If you must, turn your back to the wind or find a boulder, bush, or even a hiking buddy that you can use as a wind block. Make sure you have the replacement lens available before removing the current lens. Face your camera down and work as quickly as possible to put the new lens on. Enlisting the help of a fellow hiker can significantly speed up this process.

3. Capturing Popular Subjects

One of the joys of hiking photography is the sheer variety of subjects available to capture while out on the trail. From splendid scenery and fascinating wildlife, to alpine meadows and cascading waterfalls, hiking trails provide access to some of nature's most photogenic subjects. This chapter describes the most common scenarios you will encounter while hiking and offers advice on how best to capture them.

in this chapter:

- » Scenery
- » People
- » Wildlife
- » Plants
- » Natural Features
- » Action Shots
- » Sunrise & Sunset
- » Night Shots
- » Weather Phenomena
- » Time-Lapse Shots
- » Culture
- » Documenting the Experience

Figure 86 **Garnet Lake Reflection**
Ansel Adams Wilderness, CA
DSLR, f/16, 1.6s, 22mm, ISO 400

Figure 87 **Shepherd Girls**
Huascarán National Park, Peru
DSLR, f/13, 1/50, 20mm, ISO 400

Figure 88 **Magellanic Woodpecker**
Torres del Paine National Park, Chile
DSLR, f/7.1, 1/125, 300mm, ISO 400

Figure 89 **Clouds at the Pass**
Uttarakhand, India
DSLR, f/13, 1/500, 17mm, ISO 400

Figure 90 **Crossing the Stream**
Inyo National Forest, CA
Compact, f/8, 1/320, 6.3mm, ISO 100

Figure 91 **Starry, Starry Night**
Big Bend National Park, TX
DSLR, f/2.8, 25s, 17mm, ISO 6400

Figure 92 **Latourell Falls**
Columbia River Gorge, OR
DSLR, f/20, 2s, 27mm, ISO 100

Figure 93 **Little Tahoma at Sunrise**
Mount Rainier National Park, WA
DSLR, f/16, 1/10, 95mm, ISO 200

Scenery

One of the primary motivations for hikers is the opportunity to get outdoors and experience incredible scenery first-hand. Hiking brings you in close contact with a wide variety of scenic subjects, including mountains, forests, rivers, lakes, alpine meadows, deserts, waterfalls, glaciers, and coastline, just to name a few. While scenics can often be appealing to the eye, they can be difficult to capture in your camera with the same dramatic impact as being there in person. Lighting and time of day, distance from your primary subject, choosing a clear and identifiable subject, and composing with depth to draw the viewer into the scene pose significant challenges to the hiking photographer. Should you attempt to capture the whole scene or focus in on specific details? What kind of lighting, time of day, or season of the year is optimal? What is the best vantage point from which to shoot? These are just a few of the questions you should consider when photographing landscapes.

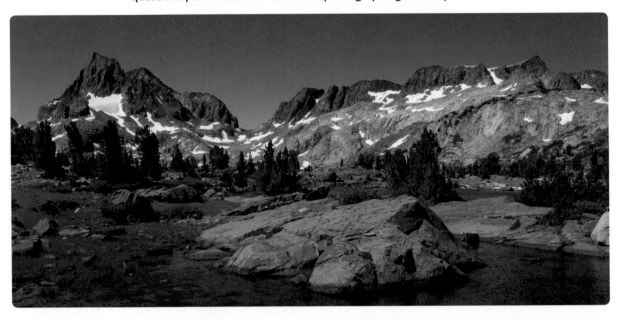

Figure 94

Thousand Island Lake

John Muir Trail, Ansel Adams Wilderness, CA

Compact, f/8, 1/400, 6.9mm, ISO 100

When composing a scenic shot, pay attention to the rule of thirds. Create depth by including interesting elements in the foreground, middleground, and background. Often, we are drawn to the dramatic peak of a mountain, for example, but neglect to showcase what is in front of the mountain. Look to include leading lines and strong foreground elements, such as flowers, rocks, animals, or shoreline, to draw the viewer into the scene and add impact.

For grand landscapes, shoot with greater depths of field (f/16 to f/22 and beyond if possible) to maximize focus from foreground to background. If you have a prominent foreground subject, make sure it is in sharp focus. Focusing on key elements manually can often get a sharper picture than using the camera's autofocus. Experiment with lenses. Most landscapes can be taken with a short range lens (18-55mm), but using a wide angle lens (10-18mm) can help capture a dramatic foreground element, such as a rock or a flower, and still show the context of the surrounding background. Move around, change your angle to the subject, and play with perspective and lighting to emphasize different features of your subject.

Lighting can make or break landscape photography. Shoot during Blue Hour and Golden Hour for the most dramatic light, but be prepared to take advantage of unique lighting situations whenever they arise. Vivid lighting often occurs in the moments just before or after a thunderstorm. Clouds add an element of interest to a scenic shot and break up the monotony of a plain blue sky. Overcast days are a good time to focus in on details like waterfalls, flowers, or forest shots. Frame your shot to exclude or minimize grey or uninteresting sky in your photograph. Consider shooting after dark. Starry skies and the Milky Way are scenic subjects in themselves and can add interest to any landscape scene.

Scenics can be challenging because of the range of light present, especially when shooting early in the morning or late in the afternoon. Tops of mountains may be brightly lit by the sun, while the foreground remains in shadow. One way to bridge this contrast is to shoot in HDR by taking three or more bracketed exposures (1-2 stops apart) and then stitching them together into a single HDR photo using post-processing software.

Figure 95 **Admiring Hemlock**
John Muir Trail, Ansel Adams Wilderness, CA
Compact, f/8, 1/200, 4.7mm, ISO 100

Figure 96 **Rock Stacks at Low Tide**
Second Beach, Olympic National Park, WA
Mirrorless, f/16, 1/25, 19mm, ISO 100

Tips & Tricks:

→ Shoot on a tripod or from a solid surface, such as a rock or log, whenever possible to reduce shake. If your camera has a self-timer feature, use it to eliminate the slight movement that occurs when pressing the shutter button.

→ Double check your horizon line and make certain that it is straight.

→ Shoot with a circular polarizing filter to reduce glare on water, crisp up the outlines of mountains and clouds, and increase the overall color saturation of your photos.

→ During midday, shooting the sky at a 90-degree angle to the sun produces the bluest skies.

→ If the scene contains moving water, like waterfalls, streams, or ocean waves, use a slow shutter speed to make the water appear smooth or silky and add impact. If the water is sufficiently still, consider shooting reflections instead. See page 74 and the following for more details on how to properly shoot natural features like these.

→ Adding people or objects, such as a backpack or boots, can emphasize the grand scale of the landscape.

→ If backpacking, try to camp near a scenic location, so you have easy access to your subject at sunrise and sunset. Remember to bring your headlamp for hiking to and from locations at night.

People

Figure 97

A Quick Catnap
Cedros-Alpamayo Circuit,
Huascarán NP, Peru
*Compact, f/8, 1/320,
4.7mm, ISO 100*

Taking pictures of your hike helps tell the story of your journey. That is why we train our lenses on everything we encounter along the way, big and small – the mountains, the rivers, the birds, and the flowers. You, too, are part of the experience, so remember to include shots of you and your fellow hikers enjoying the adventure. Including people can add an element of interest to a scene, personalize an encounter with nature, or simply suggest the scale of the landscape. Rather than relying on selfies, which often focus on the human to the exclusion of the natural surroundings, why not try some creative shots that capture the hiker in his or her element?

Most shots involving people consist of straightforward portraits and other posed shots in front of prominent features, like mountains or lakes, where the subject, more or less, directly faces the camera. Vary the pose by having the hiker look out over the edge of a cliff and capturing him or her from behind or at a side angle. Look for silhouettes at sunset that capture only the shape of the hiker while still capturing the dramatic light of the scene. Or try backlighting the subject or shooting into the sun to add a sunburst.

Figure 98 (left)

Early Morning Summit
Half Dome, Yosemite
National Park, CA
*Compact, f/8, 1/1600,
4.7mm, ISO 400*

Figure 99 (right)

Steady As She Goes
Wonderland Trail, Mount
Rainier National Park, WA
*Compact, f/8, 1/160,
4.7mm, ISO 100*

Trail shots help tell the story, too. Shoot the hiker as he or she is approaching or walking away, with the trail creating an attractive line that leads the eye of the viewer into the scene or suggests where the hiker is going. Experiment with changing perspective as well. Instead of shooting at eye-level to your subject, try getting down low, especially with a wide angle lens, and capturing the hiker from below. Shoot from above hikers on a steep descent of a mountain to amplify the verticality of the scene and dramatize switchbacks. Shoot for human details: hands on trekking poles, boots going over a bridge, eyes gazing off in the distance. At river crossings, use a fast shutter speed to capture the hiker as he or she leaps from rock to rock. At rest stops, shoot your fellow hikers as they cool their feet in a stream, enjoy a trail snack, or take a nap in an alpine meadow.

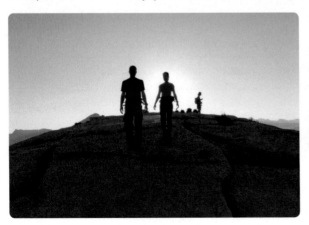

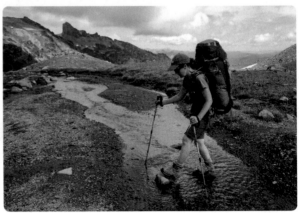

Remember to capture elements of camp life: setting up the tent, filtering water, cooking around the stove, or relaxing by the campfire. Candid shots of people often tell the story better than posed shots. Remember, there's more to hiking than just hiking.

Wildlife

Spotting wildlife on the trail can be one of the most exciting moments of any hiking trip. Often, this is simply a matter of being in the right place at the right time. While most people are eager to see animals, most wildlife is shy, wary of people, and intent on keeping a safe distance from hikers, making great wildlife photography a real challenge. Typically, a telephoto lens (300mm or higher) is necessary to create an image in which the animal fills the frame. These lenses, however, tend to be heavy, expensive, and not ideal for most hiking photography. Most hikers leave them at home due to weight and space considerations.

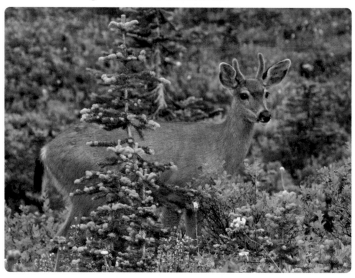

Even if you are willing to carry a telephoto lens on the trail for the rare moment when you may need it, chances are that you will not have it on your camera body when a wildlife encounter occurs. Changing lenses takes time, so having your long lens readily accessible is key. If you are lucky enough for all of these circumstances to be in place, shoot away. Wildlife encounters are special opportunities.

Before heading out on the trail, get to know your subjects as much as possible by reading about them and watching documentaries.

Figure 100

Young Mule Deer

Paradise Meadows, Wonderland Trail, Mount Rainier National Park, WA

DSLR, f/7.1, 1/640, 160mm, ISO 800

Learn about their habitat so that you will know where to find them and choose hiking trails accordingly. Check with a park or forest ranger to inquire about recent sightings and about where you may be likely to encounter particular species of animals, so you can be on the lookout for them. Be out on the trail as early in the morning and as late in the day as possible. This is when animals are most active and can be seen most easily. Fewer people are on the trail at these times of day, increasing your chances for encounters as well. Most animals tend to lay low during the heat of the day and can be difficult to spot.

When you do spot wildlife, approach quietly and avoid making sudden movements that would scare the animal away. Observe their behavior carefully so that you can anticipate interesting actions and capture them with your camera. Shoot with a telephoto lens (300mm or higher) to allow a safe distance between you and the animal. As tempting as it is to try to get closer to an animal, doing so may put a premature end to this photographic opportunity by causing the animal to flee. If the encounter is long enough, allow time for the animal to get used to your presence before slowly moving in.

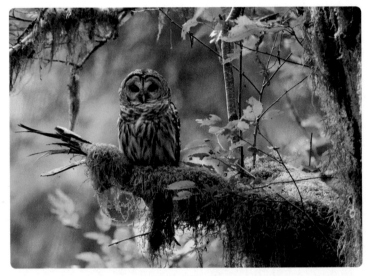

Nature ethics also remind us not to harass wildlife. Try to pay attention to whether your presence is disturbing an animal. If you notice an animal is stressed or changing its behavior because of your presence, immediately back off and leave the animal in peace. Wild animals lead difficult lives, and our behavior should not have a negative impact on them. Remember that you are a guest in their home and should always prioritize their well-being over your desire for a good photograph.

Sometimes it is so thrilling to see an animal through your viewfinder that it is easy to forget about composition. Be careful not to cut off any parts of the animal at the edges of your frame when composing your shot (unless this is an intentional choice, such as filling the frame to show only the face). It is more often prudent to zoom out and allow a little extra room around the animal than to unintentionally cut off the tip of the tail or an ear. You can always crop in tighter during post-processing. When composing your photograph, avoid crowding the animal too tightly in the frame. Leave space in the composition for the animal to move or look in the direction it is facing. Depending on the conditions, consider whether you want to take an environmental portrait showing the animal in its natural surroundings (narrower aperture) or a portrait-style photograph with an attractive blurred background (wider aperture). How far the animal is from its background may be the determining factor.

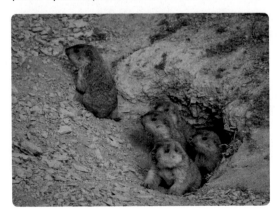

If possible, always try to shoot at eye level to the subject. Kneel down if you are photographing a smaller animal that is at ground level. The end result will do a much better job of capturing the animal as it sees the world. If an animal is above you, like a bird perched in a tree, resist the temptation to get too close. The shooting angle in this situation is often better from farther away. Shooting at a severe angle from below is not particularly flattering.

Utilize your camera's Continuous Shooting Drive Mode to get the perfect pose. When you press the shutter button down, your camera takes a series of rapid-fire shots (4-5 frames per second) that significantly increase your chances of capturing the defining moment. Make sure your shutter speed is high enough to prevent blur when the animal moves. Shooting at a minimum of 1/500 of a second is a good rule of thumb, but this can vary depending on lighting conditions and on how fast the animal is moving. Shooting at a high ISO (800 minimum) may be essential, especially when encounters happen in low-light conditions at dawn, dusk, or in the shade of a forest.

A lower depth of field can also help to increase shutter speed. If an animal is on the move, change your camera's autofocus settings to the mode (AI Servo for Canon, Autofocus Continuous for Nikon) that allows you to lock focus on your subject and track its movement. Be aware that using this mode drains camera batteries more quickly.

Figure 103 **Animal Warning Signs**
Chisos Basin Loop, Big Bend NP, TX
Compact, f/8, 1/200, 5.1mm, ISO 100

Figure 104 **Evidence of Bear & Porcupine**
Northern Loop Trail, Mount Rainier NP, WA
Compact, f/2.8, 1/50, 4.7mm, ISO 400

Tips & Tricks:

→ If expecting to see wildlife, be prepared for the encounter and change your camera settings to the wildlife settings mentioned above.

..

→ Always make sure that the animal's eyes are in sharp focus. We typically shoot in single-point AF mode to be able to lock in on the animal's eyes as quickly and precisely as possible.

..

→ Get a record shot first, and, once you are over the initial excitement of seeing the animal and capturing it with your camera, analyze your camera settings, shooting position, and framing. If the animal is still present and close enough to shoot, consider adjustments that can be made to improve the photograph.

..

→ Never approach an animal so closely that you put yourself or the animal in danger. Remember to respect wildlife and keep a safe distance at all times.

..

→ Sometimes you are never lucky enough to see wildlife on the trail. Regardless, you most likely will see evidence of animals, such as paw or hoof prints in soft soil or claw marks on trees. Remember to document these encounters, too. These photos can help tell the story of your experience, and they may be as close as you ever get to a bear or mountain lion.

Plants

Unlike wildlife, vegetation is a subject that can be seen almost anywhere. Close-up photographs of the plants, flowers, and trees that you observe while hiking add to the story of your journey. Looking for interesting flora subjects keeps your mind off your feet and helps pass the long miles. Keep an eye out for pleasing arrangements of colorful flowers, leaves, and mushrooms. Photographing details like these can be just as impressive as the grand landscapes and wildlife you encounter.

Figure 105 (left)

Sand Lady Slippers

The "W" Trek, Torres del Paine National Park, Chile

DSLR, f/11, 1/200, 85mm, ISO 800

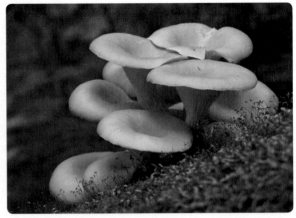

Figure 106 (right)

Jewels of the Forest

Nanda Devi Alpine Trek, Uttarakhand, India

Compact, f/2.3, 1/640, 17.7mm, ISO 100

A macro lens is ideal for capturing details of beautiful flora, but carrying a specialty lens on the trail is not always practical, especially for long-distance hiking. Some standard zoom lenses have macro settings, and a telephoto zoom lens, which you may already be carrying, can also be utilized to create striking flower portraits. Compact cameras often have a flower function designed for close-ups as well. This setting reduces the minimum focusing distance of the camera to the subject and allows for greater frame-filling shots. If you are hiking at the ideal time in an area that is known for its magnificent displays of flora, consider whether bringing a dedicated macro lens may be worth its weight. Remember that a tripod is often essential to hold the camera completely still when shooting macro photography. Also, be sure to account for extra shooting time in your travel itinerary if you are hoping to focus on shooting flora along the trail. Composing flower shots can be time consuming.

Just as with wildlife, it pays to know your flora, too. Do your research ahead of time. Learn what species you are likely to see and their habitats, so you will know where to find them on the trail. Talk to a ranger or someone else in the know to learn what is in season and whether there are any specialty species that may be seen in the area.

Figure 107

Bear Grass

Wonderland Trail, Mount Rainier National Park, WA

Compact, f/8, 1/500, 10.8mm, ISO 100

Contrasty conditions are often the enemy here, so avoid shooting flora on bright, sunny days. Instead, focus on vegetation subjects on overcast days when lighting situations are more even. Shooting early in the morning or late in the afternoon when the light is less intense can also be a solution. Look for specimens that are in prime condition and really show off the natural beauty of the subject. Flowers in odd numbers are more pleasing than in even numbers. Avoid groups of two which cause the viewer's eyes to ping-pong back and forth between the subjects.

When shooting vegetation, look for a subject that is separated from its background. Sometimes shifting your position just a few inches to the right or left can make all the difference in close-up photography. Try to shoot at an angle that is parallel to the most photogenic plane of your subject to help ensure adequate focus. Use a depth of field that is shallow enough to create a soft, blurred background but deep enough to ensure that all of the main subject is in focus. Alternatively, selective focus can be used to emphasize one detail of the subject, while intentionally blurring the rest.

Figure 108

Ladybug on Bear Grass
Wonderland Trail, Mount Rainier National Park, WA
Compact, f/8, 1/800, 4.7mm, ISO 100

Tips & Tricks:

→ Avoid shooting in windy conditions. Even the slightest motion can blur a close-up photo. As the sun rises, it tends to heat the air which in turn causes wind. The atmosphere will be most calm just before sunrise, making early mornings an ideal time to shoot flora.

→ Take a moment to "clean the scene" before shooting. Remove any distracting elements, like twigs or dead leaves, that can take away from your photograph. Look for bright spots that can be caused by the sun or white objects that will draw attention away from your subject.

→ Fill flash can be used to help illuminate the subject. Consider carrying a small reflector or even a piece of aluminum foil to help bounce light onto the subject.

→ Cut glare on shiny leaves by using a circular polarizer.

→ Dew or rain drops on leaves can add an element of interest to flora shots. Be careful not to accidentally touch or bump your subject while shooting.

→ Keep an eye out for bugs, spiders, and bees that can often be found on flowers and leaves. These critters can help tell a nature story.

Natural Features

Hiking with our camera in hand reminds us that the point of the journey is not simply to arrive at the finish line or cover a set number of miles as quickly as possible. The camera, mercifully, slows us down and causes us to appreciate the many natural features of which a landscape is comprised: babbling brooks, thunderous waterfalls, mirror-like reflections on lakes, strange rock formations, and twisted tree trunks. The challenge for the hiking photographer is deciding which of the myriad natural features on a given hike are worthy of stopping to photograph. If a large part of your motivation for hiking lies in capturing the natural beauty all around, then plan your hike accordingly. Do not race past idyllic scenes without taking the time to appreciate them with your camera. Below are some specific tips for a few of the common natural features you will encounter on the trail.

Rock Formations

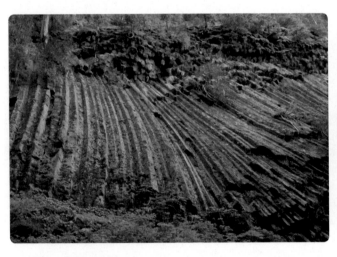 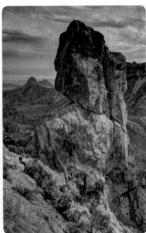

Figure 109 (left)

Andesite Columns at South Puyallup River Camp

Wonderland Trail, Mount Rainier National Park, WA

Compact, f/8, 1/25, 5.9mm, ISO 400

Figure 110 (right)

Rock Formation

Lost Mine Trail, Big Bend National Park, TX

DSLR, f/16, 1/40, 33mm, ISO 200

Tips & Tricks:

→ Search for interesting shapes, textures, patterns, or unusual formations. Rock cairns that mark the trail make great foreground subjects, too.

→ Include elements of interest, such as patches of snow, colorful flowers, or perhaps a marmot sunning itself on a rock, to help tell the story.

→ Use a wide angle lens to get close to your subject and still capture the surrounding scenery.

→ Golden light is preferable to flat midday light to warm up the scene. Blue sky with cloud formations can provide a pleasing contrast on sunny days.

→ Experiment with shallow and large depths of field. Some rock formations look best isolated from the background, while others benefit from showing the surroundings.

→ A circular polarizing filter can reduce glare on wet rocks.

Waterfalls & Streams

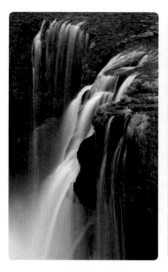 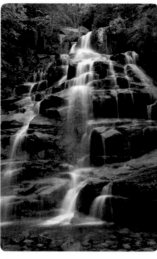 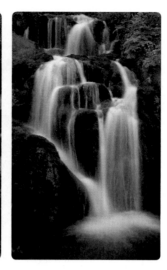

Lower Lewis Falls
Southern Cascades, WA
DSLR, f/16, 1s, 160mm, ISO 100

Cloudland Falls
Franconia Notch State Park, NH
DSLR, f/22, 0.8s, 22mm, ISO 100

Holmafoss
Asbyrgi-Dettifoss Hike, Iceland
DSLR, f/22, 1.6s, 26mm, ISO 100

Tips & Tricks:

→ Waterfalls tend to be more attractive in the spring when the flow of water is stronger. Some waterfalls flow steadily all year long, while others reduce to a trickle or dry up entirely later in the season. Do your research before hitting the trail.

→ Shoot the whole waterfall, but then use a zoom lens to focus in on details that can make pleasing abstracts. Use a tripod to ensure a tack sharp image.

→ Work the waterfall. Alter your point of view and experiment with shooting both verticals and horizontals.

→ Streams make strong leading lines that draw the viewer's eye into a larger scene. Use them as strong foreground subjects in landscapes. Look for attractive S-curves and interesting shoreline.

→ High, overcast days are best to ensure even lighting and to prevent cascading white water from being blown out. Cut out the sky as much as possible when the sky is gray and uninteresting.

→ Use neutral density filters to slow down moving water and create a silky effect. Lowering the ISO or increasing the f-stop can also help slow down the shutter speed. Aim for shutter speeds around 1" but bracket for slightly faster and slower speeds until you achieve the desired look.

→ Look for leading lines and interesting patterns in the rocks. Include green plants, flowers, or colorful leaves in the fall to add an element of color.

→ Watch out for spray from waterfalls that can coat your lens with fine water droplets. Use a lens hood to provide some protection. Check your lens surface frequently and use a soft, clean cloth to wipe your lens dry of any water droplets.

Lake Reflections

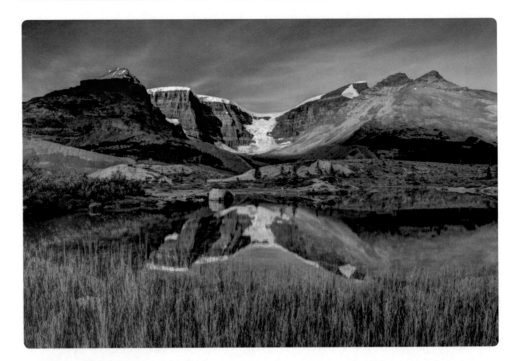

Figure 114

Athabasca Glacier Reflection

Jasper National Park, Canada

DSLR, f/22, 1/8, 17mm, ISO 100

Tips & Tricks:

→ Look for reflections that capture something dramatic, like a mountain peak or a colorful tree.

→ Shoot early in the morning (before and after sunrise) and late in the afternoon (just before and after sunset). The wind tends to be calmer then and helps produce the mirror-like surface you are looking for. Smaller bodies of water, like alpine tarns and secluded ponds, are often more still than larger lakes and produce better reflections.

→ Use a polarizing filter to cut glare when you want to see "into" the water.

→ Play with the distance from the lakeshore and camera height. Depending on the topography and what you hope to capture in the reflection, you may need to get closer or further from the lake shore or lower or higher from the ground with your camera in order to frame the reflected subject optimally.

→ Search for interesting elements, such as rocks, fog, or clouds. If you are lucky, wildlife can add that something extra that makes a good image great.

→ Use larger depths of field to get everything in focus from foreground to background.

Action Shots

Remember that you and your hiking buddies can make wonderful photographic subjects out on the trail as well. Capturing the action while hiking can often be as fun a challenge as the hike itself. Walking along a trail, summiting a peak, fording rivers, negotiating streams and rocks, jumping in lakes, and climbing over boulders make memorable experiences that are well worth documenting. Action shots are a terrific way to document the excitement of the hiking experience.

Camera accessibility is the key to capturing the moment in action shots, so any camera that can be kept handy will work. This is a great use for smartphones, compact, and action cameras. It is also a good reason to use a capture clip or harness to keep your mirrorless or DSLR handy. Typically, a standard mid-range zoom or wide angle lens will be most useful in these situations, giving you the flexibility to frame the shot as desired and to recompose as necessary as your subject moves closer to or farther away from you. Faster shutter speeds are essential to minimize blur from movement. Use higher ISOs when low-lighting is a factor.

Figure 115 (left)

Crossing the Stream

Cedros-Alpamayo Circuit, Huascarán National Park, Peru

DSLR, f/11, 1/60, 12mm, ISO 400

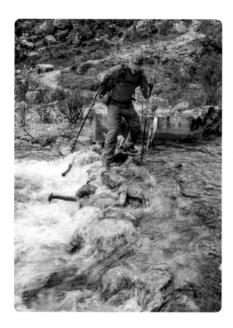

As the photographer, it can be useful to take the lead on the trail and to scout out scenarios that make for interesting action moments. Thinking ahead is the key here. If you see a stream up the trail, for example, can you pick up the pace to cross the stream first and then position yourself at a good vantage point before your friends arrive? If not, are your hiking partners agreeable to slowing down or stopping to allow you time to get in place? Perhaps they are even willing to cross a stream more than once to give you another opportunity to get the shot. Agree on a strategy with your team for documenting exciting trail moments, so that they are not alarmed if you suddenly race ahead to set up a shot.

Figure 116 (right)

Leaping Mountain Goat

Chicago Basin Trail, Weminuche Wilderness, CO

Compact, f/8, 1/640, 17.7mm, ISO 200

→ Use Continuous Shooting Drive Mode to shoot multiple frames of the action and increase your chances of capturing the defining moment in an action shot.

→ Anticipate movement. Focusing on a moving subject can be tricky. Minimize this difficulty and be ready to capture the moment by visualizing where you expect your subject to be when their action will be most interesting. Pre-focus on that point in the frame and then reframe as necessary for improved composition and lighting.

→ Check your shot for exposure, composition, and focus before moving on. If you did not get the shot you were hoping for, consider asking your buddies to recreate the scene. You may never have this opportunity again.

→ Use a small tripod with an action camera to get low and capture creative shots on the trail. The extreme wide angle makes for interesting perspectives and allows the photographer to get close to the action while still capturing the surrounding context.

→ You can also use an action camera in its waterproof housing to capture action in or near water.

→ Remember that all these tips apply to capturing wildlife action as well.

Sunrise & Sunset

Figure 117

Sunset from Golden Lakes

Wonderland Trail, Mount Rainier National Park, WA

DSLR, f/14, 1/10, 56mm, ISO 400

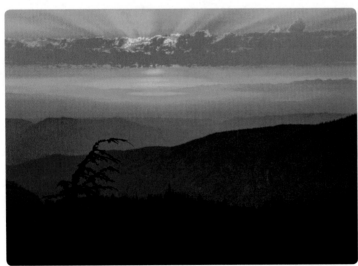

Hardly any other subject stirs the imagination or evokes emotion like a beautiful sunrise or sunset, and the hiking photographer should make shooting during these times of day a top priority whenever possible. This is often easier said than done. The most difficult aspect of capturing a good sunrise or sunset shot is simply being there. It would be embarrassing to count how many times we have set our alarm to go off in the wee hours of the morning to catch the sun's rise only to hit the snooze button until the beautiful pink shades of early morning have long faded away. Sunsets should be easier, theoretically, but the lure of relaxing and eating a hot meal after a long day on the trail can foil even the best of photographic intentions. Those who overcome these temptations and manage to crawl out of cozy sleeping bags or eat dinner long after dark are often rewarded with sublime, soul-stirring images that are the envy of all who see them.

While being in the right position at the right time of day is totally within the hiker's control, you will also need a stroke of good luck, as weather plays a huge factor in your

ability to capture beautiful sunrises and sunsets. Cross your fingers and wish for partly cloudy skies with interesting cloud formations and a small gap of sky just above the horizon. This space is necessary to allow the vibrant light of dawn and dusk to shine through and reflect off the clouds. Wispy cirrus clouds are perfect for reflecting the color of the setting sun. The still water of lakes and ponds also does a wonderful job of reflecting colorful skies. Clean air, low humidity, and calm winds are also important factors for producing ideal conditions.

Be aware that getting these conditions just right is a rare treat. Our attempts have been foiled countless times by completely clear skies or a thick bank of clouds on the horizon that totally blocks the sun's rays. Even so, we have never regretted giving sunrise and sunset shots a try. Being out on the trail earlier or later than most hikers for the possibility of capturing a striking photograph is definitely worth the effort in our opinion.

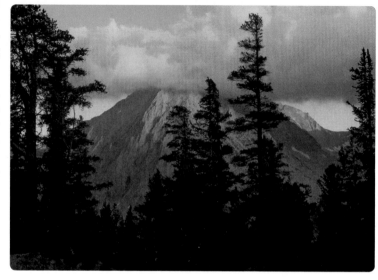

Figure 118

Sunset Over the Peak of West Vidette

John Muir Trail, Kings Canyon National Park, CA

Compact, f/8, 1/60, 10.8mm, ISO 400

Tips & Tricks:

→ Scout out your location well before shooting. The pink and orange hues of sunrise and sunset only last a precious few minutes. You will want to make sure that you are in proper position and have composed your shot well before that time. Remember to carry a flashlight or headlamp for hiking in the dark!

→ Check the internet to be aware of current weather conditions and to know exactly when and where the sun will rise or set and what direction the light will be shining.

→ When shooting into the sun, meter off the sky and then recompose your shot to gain proper exposure.

→ Underexpose your shot by up to 2 stops to bring out as much color in the sky as possible. Bracket your exposures to maximize the possibility of getting the perfect shot.

→ Look for interesting foreground elements, such as trees, rock formations, ridgelines, or even people. Consider silhouettes that can add interest to your compositions.

→ Pay close attention to your horizon line and make sure it is perfectly straight.

→ Turn around and look at what the sun is illuminating. Landscapes and clouds bathed in pink and red hues can often be more stunning than the sunsets themselves.

→ When in the mountains, be sure to stick around for 10-15 minutes after the sun has gone down for the chance to shoot alpenglow.

→ If possible, shoot in RAW to be able to bring out the most color in post-processing.

Night Shots

Figure 119

Celebrating the National Parks Centennial

Forester Pass, John Muir Trail, CA

DSLR, f/2.8, 15s, 16mm, ISO 3200

There is no need to put down your camera just because the sun has gone down. Within a few hours after sunset and especially in remote locations far from the light pollution caused by our cities, the night sky begins to reveal itself one star at a time. Nighttime offers a myriad of possible subjects for the aspiring hiking photographer. It may cost you precious hours of sleep or cause your fingers to go numb due to the cold, but the results can amaze you. If it is the heavens that attract your attention, try shooting starpoints or star trails, the Milky Way, or the full moon. Try using the full moon as your primary lighting source to create an otherworldly effect. Often the clearest skies are in colder weather months.

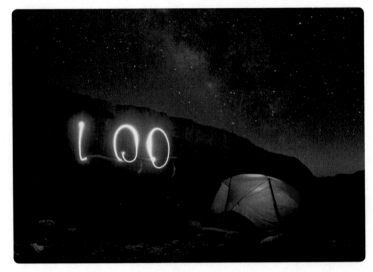

With the right equipment you can try light painting a foreground element, like a tree or rock, or illuminating your tent from within to capture the setting of the campsite you worked so hard to reach. Light writing using a pen light can be fun as well. Remember to point your camera at the campfire as you reminisce about your day's adventures over s'mores. Even the distant lights of a nearby settlement can suggest the remoteness of your journey into the wilderness.

Hikers have an advantage when it comes to nighttime photography. Distracting light from passing cars or light pollution from nearby towns can ruin a shot. Hike to vantage points where light interference from automobiles and towns is removed as an element. Backpacking is even more advantageous for nighttime shots, as you are typically far from urban light pollution and the pressure of hiking back to the trailhead in the dark is removed. If possible, choose campsites with proximity to wide open skies and interesting features that will make for good foreground silhouettes. Good places to experiment with night photography in the United States include Big Bend National Park in Texas, Arches National Park and Canyonlands National Park in Utah, the High Sierras in California, and the Boundary Waters in northern Minnesota. These places feature dark skies free of light pollution from human habitation.

>> Placing your headlamp inside an empty water bottle makes a handy lantern with soft, diffused light that can be used to illuminate your tent for nighttime camp shots. If your water bottle is full, strapping your headlamp around the outside of the bottle creates a similar effect.

Nighttime photography poses a unique set of challenges. Longer exposures are needed to capture enough light for your camera's sensor to record information. This requires fully charged batteries. Remember that cold temperatures drain your battery quicker. One solution is to keep spare batteries in your pants pocket or chest pocket so that your body heat keeps the battery warm. You may also consider carrying extra batteries specifically for night shots, although this will add weight to your pack. A headlamp with a red LED light setting is useful for night vision. This mode allows you to see your camera in the dark without having to wait for your eyes to readjust after using your headlamp. A tripod is essential to eliminate shake on long exposures. Use a backpack that will enable you to carry it comfortably and leave your hands free for trekking poles. Use a cable release, wireless remote, or even the self-timer feature on your camera to release the shutter without additional shake.

Focusing on your subject can be especially difficult at night. If possible, compose your shot during daylight and do not alter the focus. Tape down the focusing ring on your lens to prevent movement, or take a picture of the infinity scale on your lens with your smartphone for referencing after dark. If you do not manage to set up before dark, enlist the aid of a fellow hiker to use a headlamp to illuminate a foreground subject while you focus. Magnifying your image in Live View mode helps achieve a tight focus.

Star Trails

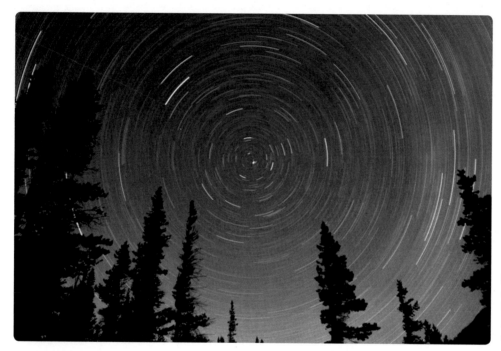

Figure 120

Star Trails
Cathedral Lake, Yosemite National Park, CA
DSLR, f/2.8, 1h21m, 16mm, ISO 100

Tips & Tricks:

→ Point your camera at the North Star (follow the ladle of the Big Dipper) to achieve a circular pattern. Point elsewhere for arcs.

→ Use the bulb setting and a cable release to open the shutter for exposures longer than 30". Shoot at the shallowest depth of field your camera will allow (f/4.5 or lower), but this time at ISO 100.

→ A typical star trail shot may take 30 minutes to an hour to complete. Test your exposure settings at ISO 3200 and 30" to be sure you are happy with the composition. Once satisfied, reset your ISO to the lower setting and utilize your camera's bulb feature.

→ Be aware that stars rotate faster the closer they are to the North Star. A wider shot will take longer for the stars on the outer rings to complete their rotation than one focused more tightly around the North Star.

Starpoints

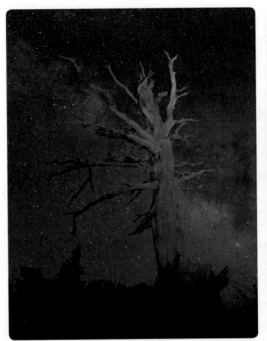 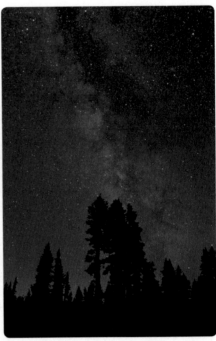

Figure 121 (left)

Light Painting beneath the Milky Way

Golden Trout Wilderness, Inyo National Forest, CA

DSLR, f/2.8, 13s, 16mm, ISO 3200

Figure 122 (right)

Milky Way

Cathedral Lake, Yosemite National Park, CA

DSLR, f/2.8, 30s, 17mm, ISO 3200

Tips & Tricks:

→ Shoot as close to the new moon as possible for the darkest skies. There are many apps and websites that can help you find optimal times to shoot.

→ Include the Milky Way in your shots whenever possible. The Milky Way is most visible in June and July in the Northern Hemisphere, and it makes a stunning addition to night sky photographs. Look due south to find it.

→ Choose a scene with a strong foreground element, such as a tree, a rock, or the ridgeline of nearby mountains. If the element is close enough, experiment with light painting by shining a flashlight over the subject for a few seconds during the long exposure. For more distant elements, some photographers use a 10,000 candlepower beam, but this is likely too heavy and bulky an item for the average hiker to carry.

→ Wait until a few hours after sunset for the sky to get really dark. It is best to shoot on a moonless night or several hours before moonrise or after moonset.

→ Use a wide angle lens, position yourself at least 15 feet away from the subject and use manual focus. Try shooting at ISO 3200, f/4.5 or as low as your lens will allow for 15" to begin with. Adjust the time your shutter is open and/or the ISO to obtain enough light to get crisp starpoints and color in the sky. The longer you leave the shutter open, however, the more the Earth's movement will cause your starpoints to blur. Movement appears in as little as 30".

Full Moon

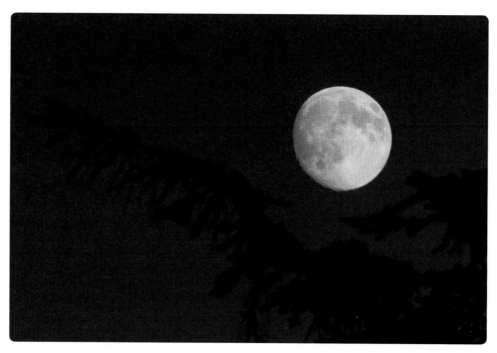

Figure 123

Moonrise over Summerland

Wonderland Trail, Mount Rainier National Park, WA

DSLR, f/11, 1/60, 300mm, ISO 400

Tips & Tricks:

→ Shoot soon after moonrise. The moon appears larger when it is closer to the horizon than it does as it rises high in the night sky. There are many apps available for your smartphone that will tell what phase the moon is in and when moonrise will occur.

→ Use a telephoto zoom lens in order to fill the frame.

→ The full moon reflects a lot of light. Try shooting in manual mode at f/11, ISO 100 with a shutter speed of 1/125 as a starting point. Adjust the ISO or shutter speed as needed. Use manual focus if possible to achieve a sharp shot. Bracket your exposures to improve your chances of getting the shot.

→ Choose a scene with a prominent ridge line or an attractive tree whose silhouette will add an element of interest to your moon shot.

→ Remember that you can use moonlight as your light source to illuminate landscapes and create surreal scenes. Shoot with a wide angle lens in manual mode at a low enough f-stop to create exposures of 30" or less. Focus on an object at least 15 feet away.

Weather Phenomena

Most hikers set out on the trail hoping for a perfect, sunny day with bright, blue skies and perhaps a few clouds, but, if you hike long enough, you know Mother Nature does not always cooperate. Sooner or later you will encounter various weather conditions that will test your resilience and make you want to hang up your hiking boots. Not to worry! What the hiker may see as less than ideal, the photographer should see as opportunity. Over time, you will discover that differing weather conditions can provide unique conditions for creative photography, so embrace the challenge!

Rain can bring with it unusual cloud formations or dramatic lighting conditions, which may include saturated colors, rainbows, or even "God light". Waiting out a storm? Consider shooting raindrops as they hit the surface of a lake with a fast enough shutter speed to freeze the water droplets or slow down your shutter speed to blur the action of the water and convey the feeling of what it is like to be in a downpour. Once the rain stops, remember to look for water droplets on leaves and vegetation. Waterfalls often make fantastic subjects on rainy days as the addition of rain increases the waterfall's flow, making it even more attractive to photograph. Capturing lightning (be careful!) can be a fun challenge and a dramatic way to show the power of nature.

Fog rolling in off the ocean or obscuring an island on a lake can create a moody and ethereal effect that is quite beautiful in photographs. With colder weather comes frost on leaves, snow on berries, and ice formations, including icicles and frozen waterfalls. Falling (or fresh fallen) snow can completely change a scene and help tell a story. Look for a hiker's fresh tracks through the snow or possibly an animal's footprints. Even windy conditions can offer creative options. Consider shooting wave action on an ocean or a lake or slowing your shutter speed down to capture the wind blowing the leaves of a tree or through tall grasses.

The primary challenge of weather photography is keeping your gear dry. Make sure you protect your camera body and lenses and store extra batteries and accessories in a dry place. Waterproof bags for your camera equipment are essential. Hikers should have a rain cover to quickly cover their backpack. You should always carry a lightweight rain jacket and pants to keep you dry. Even so, it is possible to shoot in wet conditions if you are careful. Several companies make waterproof sleeves that surround your entire camera, leaving only the lens exposed. A lens hood can help keep mist and light rain off the lens glass itself. Some hikers carry an umbrella and even mount it to their backpacks, so they can walk hands-free

Figure 124

Rainbow over the Kali Gandaki River

Annapurna Circuit, Nepal

DSLR, f/16, 1/60, 35mm, ISO 400

Figure 125

Morning Mist

Reflection Lakes, Mount Rainier National Park, WA

DSLR, f/16, 1/8, 27mm, ISO 200

and still have overhead protection. It is a good idea to carry absorbent towels to wipe water droplets off your gear and keep silicon packets in your bags to absorb additional moisture that will inevitably collect.

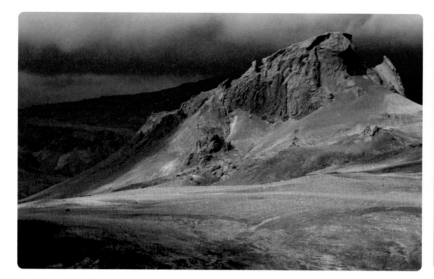

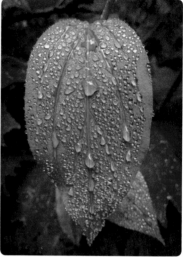

Weather photography requires flexibility, patience, endurance, and a little bit of creativity to find the shot and tell the story. Carry a tripod, of course, but also be willing to shoot handheld if you have sufficient shutter speed to avoid shake. Experiment with wide angle, standard range, and telephoto lenses. Above all, be careful. Weather conditions can change rapidly in the field and turn a pleasant hike into a dangerous situation. Know the weather patterns that are likely to occur in the area you are hiking during the time of year you plan to be there. Check the forecast before heading out on the trail. Learn to "read" the skies for danger signs. Be willing to suspend your photography to seek shelter, if necessary, and always retreat below treeline to avoid hail and lightning. Safety first!

Figure 126 (left)
Þórsmörk Valley View
Laugavegur Trail, Iceland
DSLR, ƒ/20, 1/100, 85mm, ISO 400

Figure 127 (right)
Morning Dew
Wonderland Trail, Mount Rainier National Park, WA
Compact, ƒ/4, 1/80, 4.7mm, ISO 400

Tips & Tricks:

→ Look for dramatic light before and after thunderstorms. Breaks in the clouds can create unusual lighting conditions that produce excellent images.

→ When shooting snow, pay attention to your histogram and consider overexposing by as much as a full stop or two to compensate for the way that a dominant white scene can trick your camera's light meter.

→ Dress appropriately for the conditions. Invest in quality rain gear. Wear layers and carry a hat and gloves. Hypothermia can set in quickly if you are not careful.

→ Be sure to dry your camera equipment well after shooting in wet conditions.

→ When shooting in extreme cold, be careful when bringing your cold equipment indoors. Keep your gear inside its bag or wrapped in a heavy coat for as long as possible before removing it. Let it warm up slowly to room temperature to prevent condensation forming inside the camera body and lens.

Time-Lapse Shots

Time-lapse is a fun and creative type of photography that is used to tell the story of motion over time by showing events happening faster than they occur in reality. This can be done in a few different ways. Some time-lapse photography involves taking a series of images of the same subject at pre-determined intervals of time and then compiling the images into a video. This type of time-lapse can be great for capturing the movement of stars, clouds, or waves, the setting of the sun, or even the opening of a flower bud.

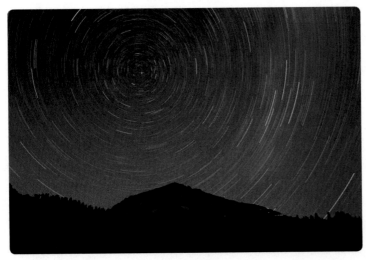

Figure 128

Star Trails

Lassen Volcanic National Park, CA

DSLR, f/3.2, 1h, 16mm, ISO 100

Another type of time-lapse photography involves superimposing several photos into a single image, where the main subject "moves" by appearing in several different positions in the final composition. This method of time-lapse photography could be used to show the progress of a hiker at several different points along the trail or the moon as it rises in the night sky. Time-lapse can also be achieved with just a single exposure. In this case, a slow shutter speed is used to blur motion as it happens. This technique can be used to create stunning photographs of moving clouds, waterfalls, and star trails.

Time-lapse photography requires a little bit of planning. First, choose your subject and compose your shot to ensure that any movement you wish to capture occurs within the camera's field of view and does not go out of the frame. Second, determine the length of your event, in other words, how much time you will need to capture the movement of your subject. If you are shooting star trails, for example, you will need a longer time period (30-60 minutes) in order to capture a sufficient rotation of the stars. If you are shooting cloud movement on a very windy day, you may only need a few minutes. If you are shooting a hiker moving down the trail, 10 or 20 seconds may be sufficient. Third, determine the interval or how much time should elapse between shots, i.e., how many frames per second, per minute, or per hour the camera will take.

Once you have made these preliminary determinations, it is time to shoot. A tripod is an absolute must for shooting time-lapse photography. You will also need an intervalometer that allows you to set the time interval between exposures. Some cameras have this built in, while others may require the purchase of a separate accessory that functions much like a cable release. After you finish shooting, you will need to process your images. Here you have an option depending on what you want the final product to look like. If you want a single image, you will need to stack and blend your images together in post-processing. If you want a video, you will need to import the images into a video editing program, like Quicktime or iMovie, to create your movie. The primary challenge for the hiking photographer is committing enough time to this fairly specialized type of photography. One second of video is typically comprised of 30 still images. You will need to capture a lot of images to create even a short video. A 10 second video, for example, requires 300 images. If you are shooting

one image every minute, you will collect 60 images in an hour. At that rate it would take 5 hours to collect 300 images for a 10 second video! Adjusting your time interval can speed this process up, but the speed of the action should ultimately determine the time interval. If you are shooting a slower-moving event, such as the the opening of a flower bud or the emergence of the stars at night, the interval between shots will be longer (1 frame/minute) than if you are shooting a faster-moving event with more action, like a hiker walking down the trail or clouds racing across the sky on a windy day (1 frame/5 seconds). For this reason, time-lapse photography may be more suitable as an activity in camp at night than when you are out on the trail during the day.

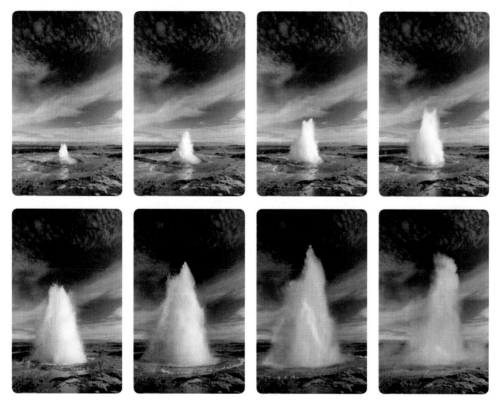

Figure 129

Strokkur Geyser
Golden Circle, Iceland
DSLR, f/11, 1/160, 10mm, ISO 400

Tips & Tricks:

→ Battery life becomes an issue the longer the event is, especially when shooting in cold weather. Make sure you start with a fresh battery.

→ For time-lapse videos, start with an empty memory card. Set your camera to record the smallest JPEG images possible. Time-lapse photography does not require the highest quality image, and you may be taking hundreds or even thousands of images to capture a single event.

→ One way to simulate time-lapse is to shoot in high continuous mode or burst mode. This is especially useful for fast moving subjects like erupting geysers. The resulting images can be assembled into a collage that shows the progress of the event.

Culture

Hiking trails in the U.S. are most commonly found in protected areas like national parks and forests, but this is not necessarily the case in foreign countries. Many countries outside the U.S. offer fantastic hiking opportunities through stunning alpine scenery but in places that are inhabited by people. Often times, the hiking trails in these countries were developed by local villagers, not for recreation but as a means of traveling from village to village. Many of these countries, including Nepal, India, Bolivia, and Peru, have a well-developed trekking industry, where hikers can travel the same footpaths that have been used by locals for hundreds of years. In addition to the opportunity to see stunning natural scenery, international hiking trips offer visitors a wealth of opportunities to photograph fascinating mountain cultures that are far removed from the conveniences of the modern world.

Figure 130 (left)

Ladakhi Villager

Stok Kangri Circuit, Ladakh, India

Compact, f/2, 1/2000, 4.7mm, ISO 100

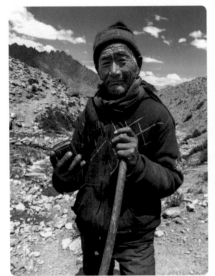

Figure 131 (right)

Prayer Flags at Ganda La Pass

Ladakh, India

DSLR, f/11, 1/160, 26mm, ISO 100

While it is possible to arrange your own trip and trek independently in most countries, there are plenty of reputable outfitters that will arrange all of the logistics for you. From planning your route and arranging local transportation to providing guides, food, and equipment, guided trips take all the pressure off, leaving you free to enjoy the experience. Many U.S.-based companies offer trips to these exotic regions, but we have found from experience that booking directly with local outfitters is a great way to go. Not only is it more affordable, but it often allows you to customize your itinerary and trek privately rather than being part of a larger, organized trekking party. As a hiking photographer, having the freedom to stop and photograph – what you want, when you want, and for as long as you want – without the pressure of following a group's time schedule is invaluable.

While using U.S.-based companies may make booking the trip a bit simpler, you definitely pay for that convenience. By going directly to the local outfitter, you can save significantly. Depending on your trekking destination, a fully outfitted trip, with a guide, cook, and additional support staff, can cost as little as $100 per person/day, a fraction of what most U.S.-based companies charge. Travel resources, such as websites, blogs, and independent travel guidebooks, offer helpful advice on choosing reputable local outfitters.

Trekking internationally is a fantastic way to experience a different culture. In addition to the wonderful hiking, it offers the opportunity to sample regional cuisine, meet local villagers, and observe customs and rituals of mountain life that have not changed for centuries. As you pass through charming, isolated villages, you often will see people harvesting crops, shepherding their flocks, transporting goods, and performing daily tasks out in the open. There is a myriad of great subjects to photograph along the trail. Keep your eyes out for traditional dwellings, remote temples, colorful clothing, prayer flags, and other details that suggest your exotic location.

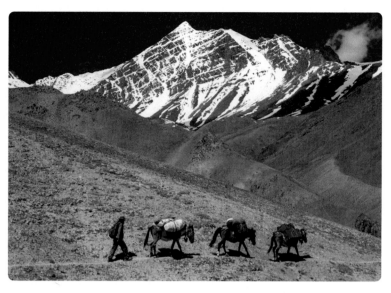

Figure 132

Descent from Ganda La Pass
Ladakh, India
DSLR, f/14, 1/80, 56mm, ISO 200

Shoot for variety and authenticity and look for ways to engage in local culture whenever the opportunity presents itself. On our culture treks, we have had the opportunity to milk goats, visit shepherd dwellings to observe traditional cheese making, and even trade our backpacks for wicker baskets used by locals to transport crops, all because we took a little initiative to interact with the people we met along the trails. It is important to be respectful of the people and their culture. As photographers, we always try to remember that we are guests in someone else's country. The language barrier often can be a challenge when photographing in foreign locations. It never hurts to learn a few phrases in the local language. This small courtesy often goes a long way to building rapport with those you meet.

When language is a challenge, having a local guide can help bridge the language gap. Your guide can make introductions and help you get the most out of your experience. When you meet someone you would like to photograph, take the time to introduce yourself, interact with them, and try to learn a little about them before pulling out your camera. Taking an interest in their lives demonstrates that you see them as a person, not simply a photo opportunity. It is amazing how just a short conversation can help establish comfort and trust and result in more natural looking portraits.

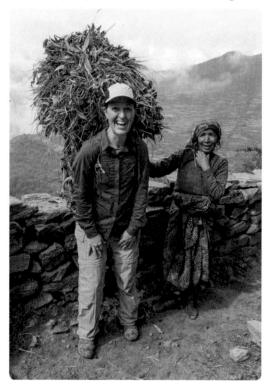

Figure 133

Sharing the Load
Nanda Devi Alpine Trek, Uttarakhand, India
Compact, f/8, 1/320, 5.5mm, ISO 200

Documenting the Experience

Figure 134

Narrow Log Bridge
Northern Loop Trail,
Mount Rainier NP, WA

*Compact, f/8, 1/20,
4.7mm, ISO 400*

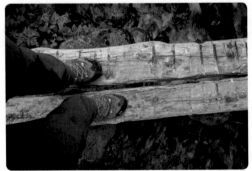

In addition to shooting all the great nature subjects you see while you are hiking, be sure to use your photography to document the experience of your adventure. As bloggers, we have found that, in addition to seeing beautiful nature subjects, people really want to know what it is like to actually be out on the trail. Particularly if you are going backpacking, people are curious about the logistics. What do you eat? Where do you stay? How do you bathe? What do you carry? How do you fit it all in your pack? How do you protect your food from bears and other critters? Photography is an excellent way to illustrate your answers. Words can go some distance to explaining the experience, but photographs can convey the adventure in ways that words simply cannot.

Shoot for details that bring people along on the journey with you. Trail shots are useful for showing context and demonstrating the conditions and difficulty of the hike itself. Trails can provide attractive leading lines in landscape shots. Including a hiker can suggest the scale of the surrounding landscape. Remember to shoot from different perspectives, with the hiker coming toward the camera or moving away from it. Switchbacks offer a good opportunity to shoot from above or from below your fellow hikers. Shots taken from your point of view help the viewer imagine what it is like to be in your boots.

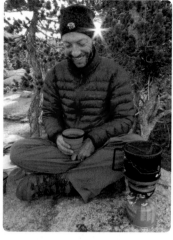

Figure 135 (left)

Breakfast at Second Beach

Olympic National Park, WA

Mirrorless, f/4, 1/200, 23mm, ISO 400

Figure 136 (right)

Enjoying Morning Coffee

Cathedral Lake, Yosemite National Park, CA

Compact, f/8, 1/50, 4.7mm, ISO 400

Document what you see and do along the trail by photographing your friends picking berries, smelling the flowers, or gazing in awe at wildlife and magnificent scenery. Rest stops can be a great time to capture the lighter moments, when your hiking buddies are taking a quick nap, enjoying a snack, or cooling their feet in a pleasant stream. And, of course, be sure to document those hard-earned achievements when you celebrate making it across a river, to the top of the mountain or even back to your car. All of these unscripted moments capture the human element of your hiking experience.

On a backpacking trip, hiking is only half of the experience. After a long day on the trail, there is nothing better than finding a great place to camp for the night. Sleeping out in the woods, far from the comfort and conveniences of home is an amazing experience, so take the time to document what makes backcountry life so special. Photograph your campsite. Include shots of your tent, both from the outside and from the inside. Shoot with a wide angle lens to include the interior of the tent as well as your feet in the foreground and

Figure 137

Tent with a View

Zion National Park, UT

Action, f/2.8, 1/280, 3mm, ISO 100

the incredible view outside. Get shots of you and your hiking buddies enjoying camp life – filtering water, cooking dinner, and singing around the campfire. Remember to include quieter moments as you read, relax, journal, or enjoy that sunset view over a hot cup of coffee.

Not every picture needs to be a well-composed masterpiece. Photography, first and foremost, should be fun, and sometimes it is the simple, candid shots we treasure most. We love to look back at old photographs of our previous hiking trips and relive the experience, so take the time to capture your personal journey on the trail.

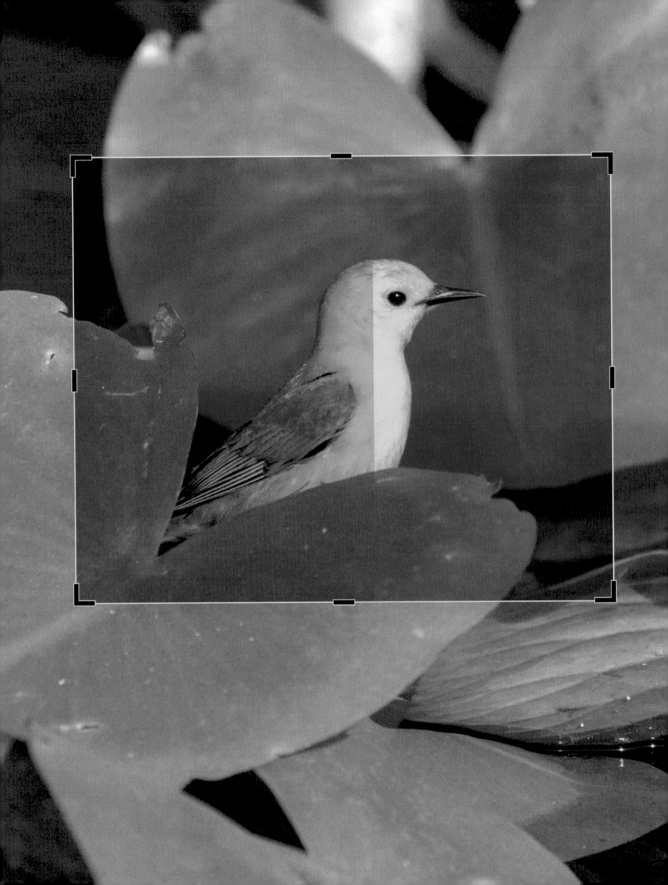

4. Post-Processing Images

Ask any photographer, and most will tell you that it is far more enjoyable to spend time in the field taking photographs than it is to sit behind the computer processing images. In order to maintain a happy balance between shooting and processing, it is key to develop an efficient workflow at home, so you can spend more time out on the trail doing what you love. This chapter guides you through the essential steps of managing your digital files and introduces several popular tools that will have you editing and sharing your amazing photographs in no time.

in this chapter:

» **Organizing**

» **Editing**

» **Archiving**

» **Sharing**

» **Streamlining**

Figure 138

Prothonotary Warbler

Indiana Dunes State
Park, IN

*DSLR, f/8, 1/1250,
400mm, ISO 400*

Organizing

Many casual photographers do not bother organizing images. They take pictures, leave them on their cameras and mobile devices, and use them maybe once or twice – to post on social media or to share with friends and family. As a result, many pictures get lost, and memories are gone forever. Keeping your digital files organized is the best way to prevent this from happening. It is also a prerequisite for efficiently completing all subsequent processing steps, which will ultimately increase the overall enjoyment of your trail photography.

Transferring Digital Files

The first step in post-processing is to upload your images to a computer that has the editing software you will use to organize and enhance your photographs. Depending on the hard drive space available on your computer and the amount of photographs in your collection, you may not want to store your images directly on your device. While each digital file may not be particularly large, the number of images adds up quickly and can take up considerable space on your computer's hard drive. Consider purchasing an external hard drive with additional storage space that can be dedicated to your photography. These days, additional space is quite affordable. You can add terabytes of storage for a reasonable price.

The photo editing software program you use plays a role in deciding where you choose to store your photographs. Some editing programs, like Apple's Photos, manage how and where your files are stored. Simply insert your memory card into a card reader and have the software import your images. It will create a file structure for your photos behind the scenes. Then create and name albums to help organize your photos in a way that makes sense to you, perhaps by photographic destination or the name of the trail hiked. Most programs allow you to nest albums inside each other. This allows you to further organize your trip, perhaps by day or by subject matter (i.e., landscapes, flora, fauna, or camplife).

Figure 139

Transferring Image Files to the Computer

DSLR, f/8, 1.6s, 23mm, ISO 800

Other programs, like Adobe Lightroom, allow you to have more control over the import process, if you desire. You can choose to simply import and have the program automatically create the file structure, or you can control that process. In this case, start by creating and naming folders on your computer or external hard drive in a way that makes organizational sense to you, and then copy your images to that folder. Once the images have been transferred from your memory card to your computer, you can "import" the named folders into the program. Lightroom simply creates a link that references where the actual file is stored. The photos will appear in Lightroom already grouped into the folders you created.

Sorting & Rating Images

In either case, once the photos are uploaded and imported, the next step is to sort your photos based on quality. After a profitable day of photography on the trail, you may be working with hundreds of photos. String those days together into a backpacking trip, and you

may even have thousands of images to process. Your first job is to whittle those photographs down and determine which are worth keeping and which are not. Recognize that some photographs will have problems that are simply impossible to fix. No amount of editing can correct poor composition, blurry photos, closed eyes, missed subjects, or unattractive poses. Delete any photographs with major flaws, so that they are out of sight and not taking up valuable space on your hard drive.

Next, you will want to evaluate the photos that are left and decide which are best and worthy of being edited. With hundreds or even thousands of images to choose from, it is unlikely you will have time to edit all of them. Developing a critical eye is essential to the editing process. Most organizing/editing programs have a system for rating photos using stars, colors, or flags, for example. Look through your photographs and use your program's rating system to identify your very best shots. Concentrate on optimizing those shots first. This will save you time in the long run.

Often, you have multiple photographs of a great scene that are very similar to one another. Look at those photos critically for sharpness, framing, and pose to help determine which is the best of the group. Often the differences can be subtle. You may want to magnify the image to determine how tight the focus is. Pay particular attention to your main subject. An animal's eyes should be tack sharp, for example. Look carefully at the edges of your frame. Perhaps the marmot's tail is clipped at the edge of the photo in all of the shots except one. Consider the pose of your subject. Maybe that deer you photographed browsing in the meadow angles its head toward the camera in a way that is more pleasing in one shot than another. These are your best shots. Rank them higher than the others. That way you can sort them easily into a group of your finest images that are ready for editing.

Figure 140
Sorting and Rating Images
Screenshot

Editing

Your primary objective while shooting should be to get the absolute best photograph possible in the field. However, most images do not come out of the camera looking their best, and even good images can benefit from simple fixes or enhancements in post-processing to make them great.

Common Fixes

The first step of editing is to recognize minor deficiencies that need correction. Perhaps your image is underexposed or has a crooked horizon line. Perhaps the colors appear flat, or the photograph contains distracting details that should be cropped out. Most post-processing applications and software programs feature a similar set of basic tools that can be used to fix these common problems and optimize your image.

Standard Toolbox

These basic tools are standard and represent a typical workflow. Basic post-processing programs only offer global adjustments that affect the overall image, while more advanced programs have ways to make local adjustments that apply the effect to only the desired part of the image. Any digital file can benefit from optimization. It is important, however, to note that many of these tools work better on RAW files than JPEG files, since RAW files contain more digital information with which to work. While you certainly do not have to use all of these tools on every photograph, it is a good idea to experiment with each of them to get a feel for how they work and understand their effect on your photos. Develop a critical eye and use your best judgment to achieve a pleasing final image.

Composition Crop

Effect on the image:
Trims the image of distracting elements and draws attention to your subject

Typical use cases:
Cropping is one of the simplest yet most powerful tools that can be used to improve your images. The crop tool allows you to draw a box of any size around what you want to keep in the image and adjust it to your liking by reframing what the viewer sees. If the subject appears too small in the initial image, use the crop tool to make your subject appear larger and more prominent in the frame. If there is too much sky or foreground, use the crop tool to emphasize scenery that is more captivating. Remember that one of your main goals is to simplify your composition, and cropping your image can help with this. Crop tools often have an overlay displaying horizontal and vertical lines representing the rule of thirds. Use these guides to position your main subject appropriately and keep your composition well-balanced and interesting.

Figure 141

Steller's Jay
Rocky Mountain National Park, CO
DSLR, f/5.6, 1/100, 150mm, ISO 100
(left) original, (right) cropped

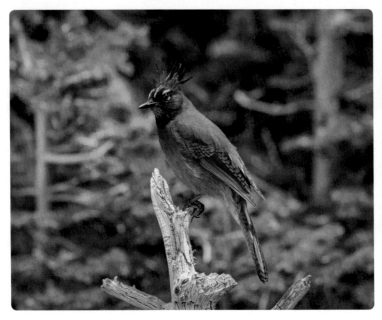

Rotate

Effect on the image:
Adjusts the horizon line of your photo or straightens vertical elements

Typical use cases:
When shooting landscapes, getting the horizon line straight is an absolute must. This sounds simple, but you would be surprised at how easy it can be to overlook horizons when you are staring at gorgeous scenery through your viewfinder. Luckily, the rotate tool can come to the rescue and help fix this common error by allowing you to get the horizon line truly straight. The rotate tool can also be used to adjust strong vertical elements, such as trees, so that they appear parallel to the edges of the frame. Be aware that you are also cropping your image when you rotate, so keep an eye on the edges of your frame to make sure that you are not inadvertently clipping important elements of your image.

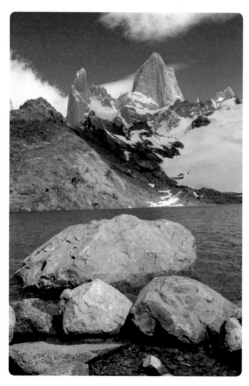

Figure 142
Laguna de Los Tres
Parque National Los Glaciares, Argentina
Compact, f/8, 1/500, 6.1mm, ISO 100
(left) originial,
(right) horizon line fixed

Exposure

Effect on the image:
Adjusts the overall lightness/darkness of the image, primarily on midtones

Typical use cases:
Despite all the amazing technology that is packed into digital cameras, it can still be difficult to obtain perfect exposure in the field. Most of your images will appear too bright, indicating that they are overexposed, or too dark, indicating that they are underexposed.

 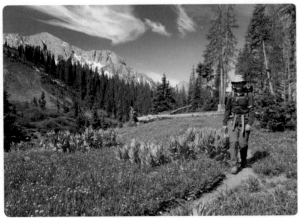

Backpacking in Chicago Basin

Weminuche Wilderness, San Juan Nat'l Forest, CO

DSLR, f/16, 1/100, 16mm, ISO 400

(left) original, (right) exposure fixed

Adjusting the exposure should always be one of your first corrections. Exposure adjustments lighten or darken the image globally. Be wary of over-adjusting to the point where you are clipping the whites or blacks in your image. Keep an eye on your image's histogram as you make your adjustments to prevent this.

Contrast

Effect on the image:

Adjusts the difference between light and dark tones, making the blacks appear darker and the whites appear brighter

Typical use cases:

An image lacking contrast appears flat and dull. This frequently occurs when shooting on overcast days when there are no shadows or when shooting in bright daylight when subjects appear washed out. Adjusting contrast can add some punch and draw out details in your image that appear muted.

Sky Pilot at Forester Pass

John Muir Trail, Kings Canyon National Park, CA

Compact, f/8, 1/640, 4.7mm, ISO 100

(left) original, (right) contrast adjusted

Highlights

Effect on the image:
Increases detail by darkening highlights, brings back detail in the brightest area of an image

Typical use cases:
Bright areas of your photo, like clouds in the sky or snow on mountain peaks, often appear white and featureless. Using this slider can recover details lost in the highlights.

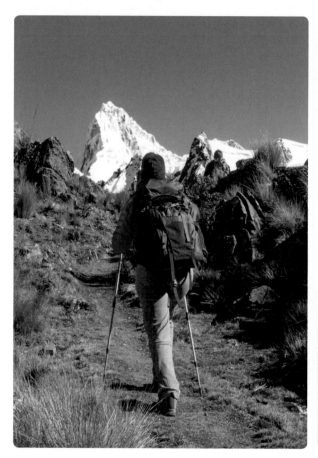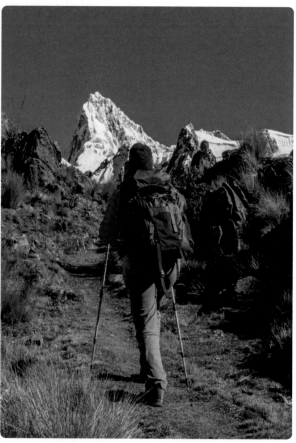

Figure 145 **Climb to Alto Pucaraju Pass** Cedros-Alpamayo Circuit, Peru *Compact, f/8, 1/640, 11.8mm, ISO 250 (left) original, (right) highlights adjusted*

Shadows

Effect on the image:
Increases detail by lightening shadows, brings back detail in the darkest area of an image

Typical use cases:
Dark areas of your photo, like the a hiker's face in the shadow of a hat or the recessed areas in a forest scene, often appear black and featureless. Using this slider can recover details lost in the shadows.

Figure 146

On the Shira Plateau

Lemosho Route,
Kilimanjaro National Park,
Tanzania

*DSLR, f/16, 1/40, 21mm,
ISO 200*

*(left) original,
(right) shadows lightened*

Whites

Figure 147

Sunrise over Stok Kangri

Ladakh, India

*Compact, f/6.3, 1/640,
4.7mm, ISO 400*

*(left) original,
(right) whites adjusted*

Effect on the image:
Defines the true white in an image

Typical use cases:
Certain scenes can be difficult for your camera to meter correctly. Incorrect metering can cause white areas in your photo, such as snow-capped peaks, to appear gray. Using this slider adjusts the white areas in your image and helps ensure that they appear truly white.

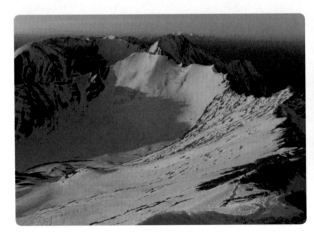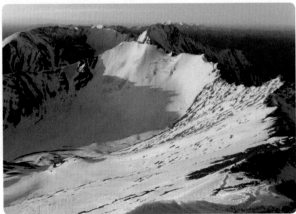

Blacks

Effect on the image:
Defines true black in an image

Typical use cases:
Certain scenes can be difficult for your camera to meter correctly. Incorrect metering can cause dark areas in your photo, like shadows, to appear gray. Using this slider adjusts the black elements of your image and helps ensure that they appear truly black.

Clarity

Effect on the image:
Adjusts contrast in the midtones

Typical use cases:
Images shot on overcast days often appear dull. Using this slider brings out texture and detail and improves sharpness in the midtones without affecting the brightest and darkest areas of a photograph.

Figure 148

Morning Coffee
John Muir Trail, Sequoia National Park, CA

DSLR, f/16, 1/40, 27mm, ISO 800

(left) original,
(right) midtones adjusted

Vibrance

Effect on the image:
Adjusts the intensity of only the more muted tones and colors in an image

Typical use cases:
When some of the colors of your image lack punch, using this slider can boost their color while leaving the others alone. Vibrance can also be used to decrease the color intensity of areas of your photo that appear too garish. Vibrance is good at recognizing skin tones and keeping them natural-looking, so it is a safer adjustment to use than saturation when fellow hikers are featured prominently in a photograph.

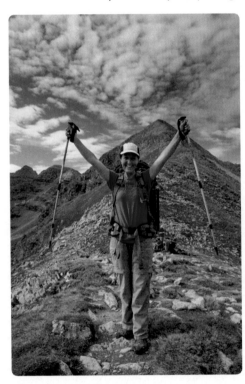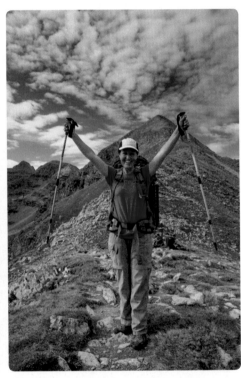

Figure 149

Buckskin Pass
Four Pass Loop, CO
DSLR, f/16, 1/80, 17mm, ISO 400
(left) original, (right) vibrance increased

Saturation

Effect on the image:
Uniformly increases the intensity of all colors in an image

Typical use cases:
When all of the colors of your image lack punch, using this slider can boost color intensity. Increasing the saturation works globally to make all the colors in an image appear richer and more intense. Decreasing saturation can also be used to tone down color or even remove it entirely to convert an image to monochrome. Saturation is a more dramatic effect than vibrance. Saturation should be used with caution so as not to produce colors that look garish or unreal (unless you are doing so for creative purposes).

Figure 150 **View from Marie Lake** John Muir Trail, Ansel Adams Wilderness, CA *Compact, f/8, 1/500, 4.7mm, ISO 100 (left) original, (right) saturation increased*

Temperature

Effect on the image:

Adjusts the color temperature of an image to produce a warmer or cooler feel

Typical use cases:

Different lighting conditions, such as deep shade, and ambient colors, such as green foliage in a forest, can alter the color temperature of a scene, making it appear unnatural. Using the temperature slider can remove color cast and restore a scene to its true colors.

Figure 151

Sylvia Falls

Wonderland Trail, Mount Rainier National Park, WA

Compact, f/8, 1/4, 10.8mm, ISO 100

(left) original, (right) temp. adjusted

Tint

Effect on the image:
Adjusts color perception to add or remove unwanted green or magenta color from an image

Typical use cases:
When the subject is surrounded by a dominant color, it can cause a color shift to take place. Use the tint slider to make colors appear more realistic. It can be helpful when adjusting skin tones or the colors of flowers to make them appear more natural.

Sharpness

Effect on the image:
Makes your image appear sharper by increasing the contrast between pixels

Typical use cases:
The sharpness of an image is highly valued in nature photography when realistic portrayal is the goal. Images that are technically in focus in the camera can still benefit from further sharpening in post-processing. Using the sharpness slider can bring out fine details and texture in your subject and add impact to your image. It can be applied in virtually every photographic situation but is especially useful for sharpening the eyes of an animal or bringing out details in fur and feathers. Be wary of over-sharpening which can cause "noise" or graininess to appear in the darker areas and make your image appear unreal. Selective sharpening is also possible where you choose certain elements of the photo, for example only the eyes, rather than the image as a whole. Warning: The sharpening tool must be used with images that already are in sharp focus. It cannot correct a blurry photo!

Figure 152
Turkey Vulture
Big Bend National Park, TX
DSLR, f/5.6, 1/2500, 400mm, ISO 400
(left) original,
(right) sharpened

Post-Crop Vignetting

Effect on the image:
Draws the viewer's attention to your subject by darkening the edges of the photograph

Typical use cases:
Our eye is naturally drawn to brighter elements in a photograph. We can help our viewer pay attention to the subject by subtly darkening the edges and spotlighting what is in the central

part of the frame. Use the vignetting slider to control how much area of the photograph is affected and how strong the effect is. Be careful not to overdo vignetting. It should be almost imperceptible to the viewer.

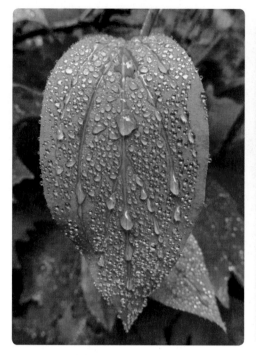 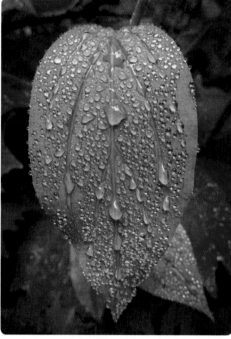

Figure 153

Morning Dew
Wonderland Trail, Mount Rainier National Park, WA
Compact, f/4, 1/80, 4.7mm, ISO 400
(left) original, (right) with vignetting

Advanced Toolbox

Most of the tools in the standard toolbox make global adjustments that affect the entire image. The tools in the advanced toolbox offer greater control by allowing you to make local adjustments to certain problem areas within an image.

Spot Removal

Effect on the image:
Removes unsightly blemishes and spots

Typical use cases:
Often in photos taken while hiking (i.e., not in a controlled environment), spots appear in an image. These can be caused by water spots or dust specks on the lens glass or dust on the camera's sensor. Do your best to avoid this by cleaning your glass regularly and only switching lenses in a controlled environment. When blemishes do appear, use the spot removal tool to eliminate them. Set the diameter of this circular tool to slightly bigger than the spot and click. The program will replace the affected area with a copy of another area of the image. You can control which area is chosen and the strength of the opacity in order to make it blend realistically. Spot removal can be accomplished by either healing or cloning. Both work similarly. Healing tends to blend better, but sometimes cloning can be more effective.

Figure 154 (next page)
Altiplano Sunset
Salar de Uyuni, Bolivia
DSLR, f/14, 1/25, 26mm, ISO 1600
(left) original with spots, (middle) tool in use, (right) spots removed

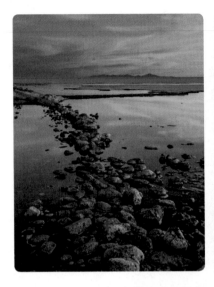 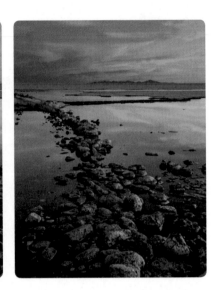

Graduated Filter

Effect on the image:
Applies a chosen effect gradually across the image in a linear fashion

Typical use cases:

Sometimes you may want to apply an effect, like exposure or contrast, to only part of an image rather than the whole. The graduated filter tool allows you to do this by blending the effect into the image. This works best when you have a clear linear division in your photo, such as a horizon line. You can control the strength of the effect by determining the size of the filter. The wider the graduation, the smoother and less obvious the chosen effect will be. This tool is particularly effective with landscape images when skies often appear overexposed while the rest of the image is properly exposed. The graduated filter can be used to darken the sky while leaving the rest of the image untouched.

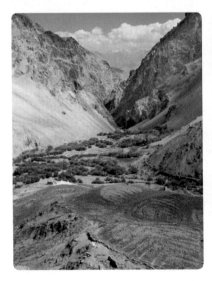 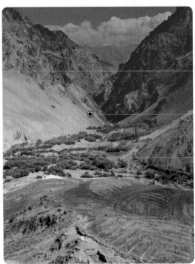 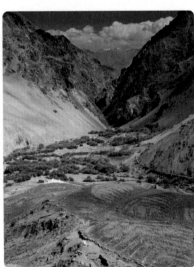

Radial Filter

Effect on the image:
Applies a chosen effect gradually across the image in a radial fashion

Typical use cases:
The radial filter tool works similarly to the graduated filter but is better for applying a particular effect to round or oval shapes. You can control how big an area of the photo will be affected by drawing an oval around it and then adjusting the size and shape of the oval. Adjust feathering to better blend the chosen effect into the image and avoid obvious and unnatural hard edges. Invert the selection to apply the effect on everything in the image that you did not select with the oval. This is a versatile tool that can be applied to many situations. For example, this can be used to selectively brighten the eyes of an animal, lighten the face of a hiker, or add color saturation to only the cone of a flower while leaving the rest of the image untouched.

Figure 156

Shepherd

Nanda Devi Alpine Trek, Himalayas, Uttarakhand, India

Compact, f/8, 1/500, 13.7mm, ISO 200

(left) orig. with dark face, (middle) filter in use, (right) face lightened

Adjustment Brush

Effect on the image:
Applies a chosen effect to a chosen area in your image

Typical use cases:
The adjustment brush tool works similarly to the graduated and radial filters but is better for applying a particular effect to more organic shapes. You control what will be affected by brushing only the area you want to adjust. Feathering helps to blend the chosen effect into the image and avoid obvious and unnatural hard edges. This is a versatile tool that can be applied to many situations. For example, this can be used to selectively tone down a sunlit branch that appears too bright, lighten up the ridge line of a mountain that appears too dark, or add saturation to the petals of a flower while leaving the rest of the image untouched.

Figure 157 (next page)

Jumping for Joy

Stok Kangri Circuit, Himalayas, Ladakh, India

DSLR, f/9, 1/1000, 20mm, ISO 800

(left) orig. with shadows, (middle) brush in use, (right) shadows removed

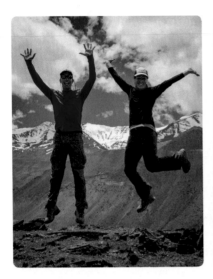
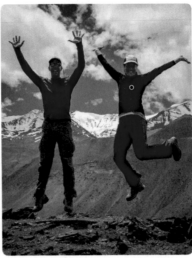
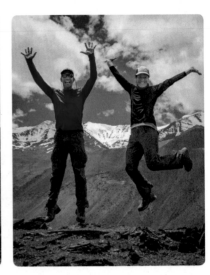

Creative Enhancements

Beyond fixing your image by making basic and advanced adjustments, you may also choose to change the reality of the photograph to achieve a more artistic effect.

Converting to Black & White

Figure 158

Mount Rainier from Reflection Lakes

Wonderland Trail, Mount Rainier National Park, WA

DSLR, f/16, 0.8s, 21mm, ISO 100

(left) original, (right) black & white

Some photographs take on a completely different feel when seen in black and white. One way to achieve this effect, of course, is to shoot in monochrome while out in the field. Most cameras have an option in their menu settings to shoot in black and white. The advantage of using this setting is that you can preview the image in black and white on your LCD screen and visualize how the scene will appear in monochrome. Shooting in black and white may not always occur to you in the field, but photo editing programs make it possible to convert a full color image into black and white back at home. So channel your inner Ansel Adams and give it a try.

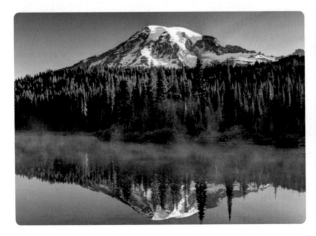
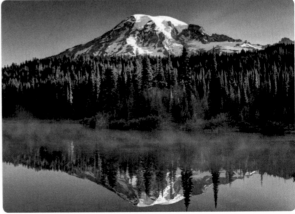

There is a variety of different methods for black and white conversion. Perhaps the easiest way is to remove all of the color by desaturating the image completely. This is done by adjusting the saturation slider all the way to the left. This adjustment can also be made with the vibrance slider, but using this tool may not remove all of the color in every photograph. The best method (using Lightroom) is to use the Black and White Mix Panel. This allows you to selectively control the tones of the individual color channels of your image and results in a final image with greater contrast and interest. Use the clarity, contrast, and black sliders for additional control. Be sure that your final image has true blacks and true whites expressed and not simply shades of gray.

Artistic Filters

Many post-processing programs allow you to apply filters to a single image to achieve different artistic effects. Many of these filters offer subtle results while others allow you to transform your photograph into a work of art. You can use filters to add patterns and textures or give your image a grainy feel. You can turn your image into a hand-drawn sketch, a watercolor painting, or even a mosaic, all with the simple click of a button. Using filters can completely change the mood or look of your photograph. Most programs offer dozens of options to play with. The only limitation is your time and imagination.

Figure 159

Desert Marigold
Big Bend National Park, TX
DSLR, f/6.3, 1/800, 300mm, ISO 400
(left) original,
(middle) Mosaic Filter,
(right) Paint Daubs Filter

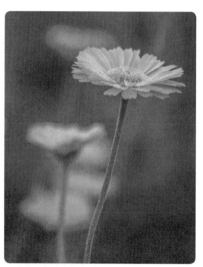

HDR (High Dynamic Range) Photography

HDR is a solution to a problem in the field, namely that the camera is limited in its ability to "see" a scene with too great a range of light. The camera cannot expose properly for an extreme contrast between brights and darks and adequately process them in a single exposure. This can be solved by taking multiple exposures and adjusting each to properly expose different elements in the scene. Typically a minimum of three exposures is necessary: one that is underexposed to account for the bright areas, one that is properly exposed for the midtones, and one that is overexposed to account for the dark areas. In post-processing, the multiple exposures are combined into a single image that properly displays the high dynamic range of light in the scene.

While HDR is a technical solution to a problem in the field, it also offers creative options back home. The multiple exposures are merged together using post-processing software. Since the multiple exposures have captured the full range of light in the scene, you can see greater detail throughout the whole image. HDR images appear vivid, impactful, and hyper-real. While it is possible to achieve a natural look in your final image, many HDR processing programs, like Photomatix Pro, allow you to choose from various presets that further alter the reality of the scene. Presets, such as Natural, Monochrome, Painterly, Surreal, Vibrant, and Enhanced, can be applied to achieve different artistic effects. It can be fun to experiment with presets to see how they affect your photograph, but often the results appear garish and cartoon-like. Depending on your goals as a photographer, HDR can offer a creative way to show what you experienced on the trail.

Figure 160

Hverir Geothermal Landscape (HDR)

Lake Myvatn, Iceland

DSLR, f/22, 1/13, 10mm, ISO 400

(bottom left) Painterly, (bottom right) Surreal

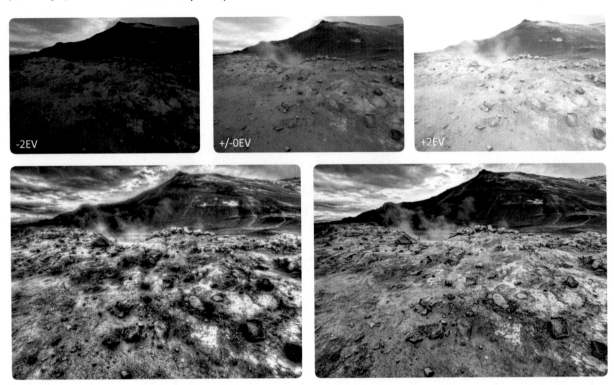

Our Take

Living in Chicago and working as teachers, we do most of our hiking photography in the summers when we are out of school. Editing is not necessarily our favorite part of photography, but we do enjoy how post-processing allows us to relive our experiences out on the trail. The act of slowly and deliberately working through our images, selecting those with the most impact, and then editing them to look their best is very satisfying for us. What better way to escape the cold winters of urban Chicago!

Archiving

The more you shoot, the more consideration you need to give to how and where you will store and backup your image files. Although single image files are relatively small, when you add them all together into a library of photographs, they can become quite sizeable and take up valuable space on your computer's hard drive.

Hard Drives

One solution to this is to buy a computer with as large a hard drive as you can afford. Increasing the storage capacity of the built-in hard drive tends to be an expensive option, and, even if you choose to go this route, space may still become an issue if you are a heavy shooter. An alternative and more economical solution to the storage space dilemma is to use external hard drives instead.

External hard drives vary in price according to their size and file transfer speed but are a much more budget-friendly option than built-in hard drives. Once purchased, external hard drives can be plugged into your computer to add additional storage space. You will need to configure your post-processing program to ensure it copies your photos to your external hard drive on import or accesses the external hard drive after you have manually copied the files there yourself.

Figure 161 **Backup Hard Drives**
DSLR, f/7.1, 3.2s, 26mm, ISO 800

Backup Routine

No matter where you choose to store your images, you will also want to consider how to backup your files. This may seem like more of a nuisance than a necessity, but it is important to remember that your photographs are priceless memories of your hiking adventures that you worked hard to capture, so take the time to protect them. All hard drives, whether built-in or external, are subject to fail at any moment, and, if they do, you could be facing the heart-breaking scenario of your images being lost forever.

External hard drives offer a convenient way to backup your image files. You can manually copy files and folders from your computer or from one external hard drive to another. There are also many programs available, like Time Machine for Mac and Windows Backup & Restore for PC, that make this process very simple. These programs can be configured to run automatically, which takes the pressure off of ensuring that you have synchronized your files. Simply keep an external hard drive plugged into your computer, and your computer will take care of the rest. If multiple versions of your files have been saved, these programs also give you the ability to choose which version you would like to restore.

Cloud Services

One problem with this scenario is that technically all of your images are still being stored in one place, your home. If something terrible were to happen there, such as a fire, a flood, or a robbery, you could still lose all of your images. For this reason, many photographers choose to backup their image files using online services. Cloud backup services vary by

provider, but, for a nominal fee, most offer backup protection using online cloud storage, external hard drives, or even to other offsite computers. Backups happen automatically and continuously, and multiple versions of your files are retained. Online backup services are convenient, too, when having an external hard drive on hand is not practical, like when traveling for an extended period of time. As long as you are able to get Internet access with your laptop, you have the ability to backup, access, and restore your files from anywhere. Crashplan, Carbonite, iDrive, SOS Online Backup, and Mozy are just a few of the popular online backup services available to choose from.

Our Take

However you choose to store and backup your files, always be sure to have your images stored in at least two different locations before you delete your images from your memory cards. In this case, it pays to be paranoid, and you would much rather be safe than sorry! Give some thought to creating a system for organizing your image files on your hard drive, too. We have been traveling and photographing together now for over twenty years. At this point in our photography lives, we have already filled several external hard drives with our photographs. At first, we simply continued adding images into folders organized by trip onto one large hard drive until it was full and then got a replacement. This system has worked fine, but we have recently decided to use smaller hard drives each dedicated to a single year, so that we could back them up easier.

Sharing

With all the time and energy you have devoted to your hiking photography, be sure to find a rewarding way to enjoy your work and share your beautiful images with others. Once you have edited your files, choose some of your favorites to print and frame for your walls. Digital photographs are nice, but nothing quite compares to seeing an enlarged print version of your image. We have a gallery of a dozen frames in our kitchen where we regularly rotate new photographs in and out. It gives us such pleasure to see our images hanging there, reminding us on a daily basis of all the beautiful places we have seen while hiking all over the world.

Figure 162

Kitchen Gallery Wall
DSLR, f/8, 1.3s, 13mm, ISO 400

Printing

Printing these days has become convenient and reasonably affordable. Once your images have been optimized, export them at full quality, and you can take them to a local store that offers photo processing or send them directly to an online service for prints. Alternatively, owning your own photo printer gives you maximum control over the quality of your prints. There are considerable costs in terms of initial printer costs, photo paper, and specialty ink, but, if you are printing a lot, it may be a worthwhile investment. Canon and Epson are considered to be the top manufacturers on

the market. We have had our Epson printer for almost a decade and love being able to print our images at home on paper as large as 13x19". Remember to check the resolution of your image to make sure that you will be satisfied with the quality of your final print. The number of megapixels in your camera and the final DPI (dots per inch) of the digital image after any cropping will determine this. As a general rule, aim for a resolution of 300 DPI, but, depending on the size of your print, a resolution of as low as 200 DPI may be acceptable.

Print Size / Megapixels	8x10"	11x14"	16x20"	16x24"	20x30"	24x36"	30x40"	40x60"
8	Perfect	Good	Low	Low	Low	Low	Low	Low
12	Perfect	Perfect	Good	Good	Good	Low	Low	Low
16	Perfect	Perfect	Good	Good	Good	Good	Good	Low
18	Perfect	Perfect	Good	Good	Good	Good	Good	Low
24	Perfect	Perfect	Good	Good	Good	Good	Good	Good
36	Perfect	Perfect	Perfect	Perfect	Good	Good	Good	Good
40	Perfect	Perfect	Perfect	Perfect	Good	Good	Good	Good

✔ Perfect Quality
✓ Good Quality
✗ Low Resolution

Figure 163

Image Quality based on Print Size and Megapixels

Turning your photographs into photobooks, calendars, and notecards are other fantastic ways to showcase your photography and share it with others. Online sites, such as Blurb, Shutterfly, and Apple's Photos, offer a wide array of professional quality templates that can help you design pleasing products that showcase your work and remind you of your adventures for years to come. Projects are simple to create using drag and drop templates and offer the ability to personalize by adding text. Prices for customized photo products can be expensive, but watch for coupons and special offers that can save you money. We have really enjoyed everything we have made, and photo products can make great gifts.

Figure 164

Our Blog: Take A Hike Photography
Screenshot

Web Publishing

You should also consider showing your images to a wider audience. Social media sites, like Facebook, Pinterest, and Instagram, are a fun way to share your photography with family and friends, and it can be very satisfying to get the instant feedback of likes, shares, and comments about your work. There are also many photo sharing websites that are geared more towards serious photographers, such as Flickr, 500 Pixels, SmugMug, and My Portfolio, that allow you to show off your work and engage with other photographers. Many of these sites give you the ability to organize your photos into attractive albums, offer direct support for buying prints and creating photo books, and even allow others to buy your work. Who knows? Maybe this could be a good source of extra income to finance your growing photography habit, so why not give it a try?

Creating a blog is another fantastic way to showcase your hiking photography. There are many wonderful, user-friendly blogging platforms, such as WordPress, Squarespace, Tumblr, Blogger, and Ghost, that allow users to create a professional-looking blog with little to no knowledge of coding or HTML. Users simply create an account, choose a theme and then use a drag and drop technique to create blog posts that are sure to impress followers. Blogs can be used to showcase your photography in a wide variety of ways. For example, you can choose to create simple Photo of the Day posts that feature your favorite images, or you can use your blog as a platform to share all the details and stories of an epic hiking adventure. The only limit is your imagination and, of course, your free time. Blogging is a great way to connect with people all over the world who share your interests and may even lead to some exciting opportunities. Sharing our work on our blog, Take a Hike Photography, has led to speaking engagements, free product trials, and even a few rewarding book projects.

Joining a Camera Club

If you are looking for a more personal connection than the Internet can offer, consider joining a local camera club in your area. Most larger towns and cities have camera clubs where you can meet face to face with other like-minded people who share your passion for photography. Camera clubs typically meet a few evenings per month and offer programs about various aspects of photography, workshops to help improve skills, outings to local photo hot spots, and even competitions and critique sessions to get feedback on your images. This is a great way to keep thinking about photography and improving your skills throughout the year, even when your next hiking adventure may be far off on the calendar. Camera clubs are open to photographers of all skill levels and give a chance for beginners to interact with more advanced photographers to get feedback and advice. Many camera clubs even offer mentor programs. We have belonged to a nature camera club in the Chicago area for over a decade now and find it very rewarding. We are constantly amazed at the talent and skills of our fellow club members who so generously share their knowledge. Being active members in a camera club has encouraged us to continually hone our skills and improve our photography over the years.

Figure 165

Sample Image Copyright Metadata

Screenshot

Protecting Copyright

Regardless of how you choose to share your images, make sure that you take proper safeguards to protect them from copyright infringement. As a photographer, your images are automatically protected by copyright the moment you create them, and, in theory, anyone must get permission from you to reproduce them in any way, shape, or form. In reality, though, it is so easy for someone to steal images posted on the Internet that you may wish to take a few simple extra measures to help protect them. Some post-processing programs allow you to add copyright metadata to your images when you export them using presets. This information is attached to each of your images and should reflect the year the photograph was taken. If your software does not have these capabilities, web services, such as theXifer and Exif Remover, allow you to add copyright data to your images free of charge.

Adding a watermark to your images may also be an effective deterrent. A watermark is an identifying feature or pattern that can be added to a photograph to help prevent it from being stolen or used without your permission. If you are posting high-quality photographs on the Internet that you would like to protect, adding a watermark is quick, easy to do and may give you some peace of mind. Watermarks can be a logo or a signature, but they should let the viewer easily know who the image creator is, so you can be contacted for permission to reproduce or even purchase your images.

People tend to either love watermarking their images or hate it, as a watermark interferes with the overall composition of the image. Some post-processing programs, like Adobe Lightroom and Photoshop, make watermarking your images a very simple process, and there are even online services, like Watermark.ws and WaterMarquee, that allow you to do this for free. If you do choose to use watermarks, try to keep them simple and tasteful. Scale and place your watermark in a position that does not overwhelm your image, but be aware that your watermark could easily be cropped out or even cloned out by advanced Photoshop users if it does not cover your entire image.

Rhyolite Landscape (including watermark)
Laugavegur Trek, Iceland
DSLR, f/16, 1/50, 17mm, ISO 400

If you do use photo sharing sites, make sure you are aware of the terms of usage and how you are agreeing to let them use any images you upload to their servers. Double check your sharing permissions on these sites, too. Allowing everyone who sees your images the ability to share them could lead to your photographs being used elsewhere without your permission. Bloggers with a little coding know-how can also add a "no right click" script into the HTML for their images to prevent viewers from right clicking to copy and paste or save their image files. It is also a good idea not to upload your images at full size and quality. Images look perfectly fine displayed on digital devices at 72 DPI, so you may wish not to export them at a higher quality than that. Not only does this make it easier for web browsers to display your images quickly, but smaller, lower resolution images are less desirable to potential thieves.

If you take all these precautions and are are still wondering if your images are being downloaded and used without your permission, you can perform reverse image searches on your computer to discover any places on the Internet where your images are on display. Google Reverse Image Search and TinEye both make this process very simple by either dragging and dropping an image from your computer or copying and pasting the image URL of a photo posted online into the search box. Within a few seconds, any place where your image is being used on the web will be shown to you. If you find that your image is being used without your permission, it is necessary to register your photograph with the United States Copyright Office to show legal ownership of your work. Several online sites, such as Myows and Safe Creative, help you register your work, search for unauthorized copies, and build cases against infringers, all for free. Another useful website to know is PlagiarismToday.

There, you can learn more about copyright infringement and what steps you should take if you discover that someone is using your work without your permission. You can also access a collection of cease and desist letters to initiate action.

Streamlining

Before you begin processing your images, it is important to think about the software you will use. Most post-processing applications available on the market today perform similar functions. They offer a means to organize, edit, and share your photos in a variety of creative ways. Some are more basic and intuitive in their operation, offering simple means to manage your images. Others are more sophisticated and require more time to learn, offering more powerful tools that give you greater creative control over the outcome. Your choice will depend on a number of factors, such as cost, compatibility, ease of use, and tools needed to accomplish your photographic goals. Ultimately, the ability to seamlessly organize, edit, and share your photographs within the same application is a convenient time saver and can help you streamline your post-processing workflow.

Desktop & Web-Based Software

The information below is designed to give you a quick overview of some of the popular options on the market today. The table allows you to quickly compare these programs based on key factors. Additional noteworthy features and limitations are discussed further below.

Software	Compatibility	Storage	Organizing	Editing	Creating	Sharing	Cost
Google Photos	Internet-based for all devices and computers	Cloud-based	Automatic and searchable	Very Basic	Basic collages and animations	Easy and built-in	Free
Apple Photos	Any MacOS device	Local and Cloud-based	Automatic and searchable	Basic	Excellent cards, books, slideshows, and calendars	Easy and built-in	Free on any Mac device
Adobe Photoshop Elements	Mac or PC desktop software	Local	Automatic and searchable	Inter-mediate	Excellent cards, books, slideshows, calendars, CD/DVD covers, and labels	Easy and built-in	$99
Adobe Lightroom CC	All devices and computers	Local and Cloud-based	Can be automatic or manual; searchable by labels, metadata (e.g., date taken, camera type, or lens used), and ratings	Advanced	Limited to photo books and prints	Must be synced with web device	$10 Monthly Subscription Plan
Adobe Photoshop CC	PC and Mac desktop computers only	Local and Cloud-based	None, but compatible with Adobe Bridge	Advanced to Pro-fessional	None	Must be synced with web device	$10 Monthly Subscription Plan

Table 2 **Overview of Popular Software Products and their Post-Processing Capabilities**

Google Photos

Noteworthy Features: Google Photos allows you to easily upload your photos from smartphones, tablets, and computers. Photos are automatically organized by date and can be grouped into albums. Photos are easily searchable by categories like person, subject, or location. Basic editing tools include cropping, straightening, adjusting for exposure, color saturation, sharpening, and vignetting. Editing is non-destructive and allows you to reset to the original photo. You can apply basic artistic filters and automatically create collages with up to nine photos. Metadata is preserved. Photos can be easily shared directly with others or via social media. Photos are stored and backed up in Google Cloud. All edits on photos are synced across all devices.

Limitations: Basic editing tools may not allow you to fix all deficiencies. Edits can only be applied globally to the whole image. No local adjustments can be made to touch up a specific area of the photograph.

Best for: cost-conscious, beginning to intermediate photographers who want to make simple edits and are looking for an easy way to share photos.

Apple Photos

Noteworthy Features: Retouch tool allows you to spot heal by simply clicking and removing. Easily create projects, such as books, calendars, cards, and even slideshows with music and themes that make your project look sleek and professional. You can also order prints. Edits are synced across all devices if using the iCloud Photo Library.

Limitations: Basic editing tools may not allow you to fix all deficiencies. All edits are global except for retouching. Software can only be used on MacOS devices.

Best for: cost-conscious, beginning to intermediate photographers who want to make simple edits and are looking for an easy way to share photos. Software gives you lots of high quality ways to display your photos.

Adobe Photoshop Elements

Noteworthy Features: Adobe Photoshop Elements offers Quick, Guided, and Expert modes to meet users at their ability level. The Elements Organizer supports visual searching, making it possible to locate photos quickly by people, places, or ratings, as well as by common subjects that are automatically identified in your photos. Guided edits show you step by step how to perform common adjustments, such as cropping, straightening, sharpening, and vignetting. Elements offers plenty of creative options for your photography, including the ability to create visual text, add textures and color themes, and apply artistic filters from an impressive gallery of options.

Limitations: None really for photographers, but lacks the advanced tools found in Adobe Photoshop CC that are used by professional graphic designers.

Best for: all photographers, regardless of skill level, but particularly for photographers newer to post-processing who want guidance.

Adobe Lightroom CC

Noteworthy Features: Adobe Lightroom CC allows you to create your own system of organization using folders and subfolders. You can rate and label your photos in order to sort them. You can also search your library using metadata, such as ratings, camera, lens, and label. Advanced editing tools give you full control over optimizing your images in a user-friendly interface. Most edits are performed with sliders, making tools intuitive to learn and use. Editing is non-destructive and can be done locally and globally.

Limitations: May require some tutorials to learn advanced functions. Not as many creative output options, but does sync with Blurb to make excellent photo books.

Best for: intermediate to advanced photographers who are serious about their photography and want superior control of their images.

Adobe Photoshop CC

Noteworthy Features: Adobe Photoshop CC is the most advanced editing program on the market. It offers a greater range of complex tools to help you optimize and manipulate your images. It has all of the features of Adobe Lightroom, but the ability to work with layers and masks allows you to selectively apply these edits with maximum control. Editing can be non-destructive and can be done locally or globally.

Limitations: Offers no internal organizing capabilities, but it is compatible with Adobe Bridge. Not as intuitive as other programs. Requires tutorials to learn advanced functions. Editing can be destructive of the original file if you are not careful with your workflow.

Best for: intermediate, advanced, and professional photographers who are serious about their photography and want superior creative control of their images.

Mobile Editing Apps

Most post-processing apps for mobile devices available on the market today perform similar functions. They all offer a means to optimize, enhance, and share your photos. Most apps are easy to learn and intuitive in their operation. Some apps are designed to perform specific tasks, such as fixing lens distortion, removing spots and blemishes, or creating composite images, while others are used to add specific artistic effects, such as blurred backgrounds, textures, and overlays. Many apps focus primarily on sharing on social media. These offer creative features, like preset filters, the ability to add captions and text, and the option to display photos in attractive frames or collages.

There are also many apps that allow you to work on your photos in a more conventional and comprehensive sense. These offer basic and advanced tools that turn your smartphone into a powerful photo editing tool. Basic apps include tools such as cropping, straightening, and adjusting brightness, exposure, contrast, temperature, color saturation, vibrance, highlights, shadows, and tint. They also allow you to apply various preset filters that can give your photos an artistic feel. Advanced apps feature selective tools that allow you to make local adjustments, such as removing blemishes and spots, and applying filters to a specific area of the image. Many of these apps also seamlessly sync your images across all your devices. Advanced apps even allow you to work with RAW files and simulate the effects of HDR.

If you are primarily shooting with a smartphone or want to share your photography taken with another camera but do not have access to your computer, using mobile editing apps to optimize and enhance your images is a great option. Almost all newer cameras have built-in WiFi capabilities, allowing you to easily transfer photos from your camera to your smartphone over a WiFi network for editing on the go. If you are shooting with an older camera or will not have access to WiFi for image transfer, you may consider purchasing a SD card with built-in WiFi. The ingenious mobiPRO SD card from Eyefi even creates its own network, meaning you can move photos from any camera to your phone anywhere in the world, even on a remote trail, far from civilization. Technology these days is so impressive!

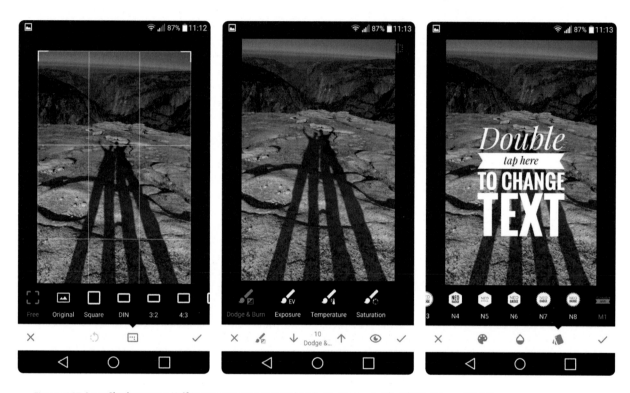

Figure 167 **Long Shadows atop Half Dome** Yosemite National Park, CA *Compact, f/8, 1/250, 4.7mm, ISO 100*
Snapseed Mobile Editing App Tools: (left) composition crop, (middle) adjustment brush, (right) text editor

New mobile editing apps are being developed and updated all the time, and many are available at no cost. If you are interested in mobile editing, it is best to spend a little time researching the possibilities, reading reviews, and experimenting with the apps themselves to find the capabilities and user interface that you like best. There are plenty of great free options, so there is no real harm in trying until you find the fit that is right for you. The following apps are meant to serve as a starting point. Some popular choices that offer basic and intermediate capabilities include Photo Editor by Aviary, Fotor Photo Editor, and Adobe Photoshop Express. If you shoot RAW files or are looking for more selective control over your image optimization and enhancement, consider apps that offer advanced capabilities, such as Snapseed, PhotoDirector Photo Editor App, and Adobe Photoshop Lightroom.

Batch Processing

Sometimes, managing your digital image files feels like a full-time job. The whole process of importing, organizing, optimizing, storing, and sharing your images can be extremely time consuming and, quite frankly, can feel a little overwhelming. If you share these sentiments, remember that technology is actually designed to save you time. Instead of getting frustrated, try to work smarter and more efficiently. Many post-processing programs offer batch processing features that can automate certain tasks. This can ultimately streamline your workflow and significantly reduce the amount of time you spend behind the computer. Batch processing capabilities vary by program, but they allow you to complete many tasks quickly, including:

- Renaming files on import

- Applying preset filters to images on import

- Adding metadata (a set of standardized information, including capture time and date, dimensions, exposure, focal length, ISO, flash, camera make, model, and lens)

- Adding copyright information and keywords which can help with sorting

- Creating albums or collection sets for images on import

- Uniformly applying frequently used adjustments, such as exposure, contrast, and saturation, to all photos or groups of photos at the same time

- Copying and pasting adjustments from one image to other images that need similar adjustments

- Turning a set of repetitive tasks into a recorded action that can be applied to other photos or groups of photos at the click of a button

- Resizing, renaming, adding metadata, and watermarking on export

Learn which batch processing features your post-processing program offers and how to use them. Remember to take advantage of them when possible, so you can focus your time and energy on the more rewarding aspects of processing your images.

Our Take

We use Adobe Lightroom for organizing all of our photographs, identifying our best photos and for basic editing of images that we share on our blog and social media. For images, we choose to print, we use Adobe Photoshop for more refined editing. For HDR images, we use Photomatix Pro for initial processing and then import them into Lightroom or Photoshop for further refinement.

Appendices

The following pages provide practical tools and useful resources that offer additional inspiration and help you further hone your hiking photography skills out on the trail and at home. Also included is information on ethical field practices for responsible nature photography as well as a list of abbreviations that are used throughout this book.

Hiking Photography Quick Guide

Understand the Exposure Triangle

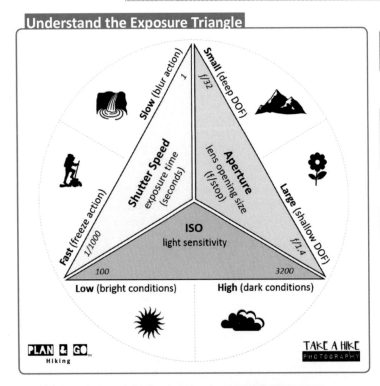

PLAN ⛰ GO
Hiking

TAKE A HIKE
PHOTOGRAPHY

Best Times for Shooting

→ Golden Hour
→ Sunrise
→ Blue Hour
→ Sunset

Improve your Exposure

→ Watch your highlights
→ Check your histogram
→ Bracket your shots

Take Sharper Photographs

→ Shoot handheld at no less than 1/60
→ Increase your ISO
→ Brace yourself, take a firm stance
→ Use a tripod and self-timer
→ Focus in Live View

Helpful Shooting Modes

→ Use Aperture Priority to control depth of field (DOF)
→ Use Shutter Speed Priority to control exposure time

Shoot in High Dynamic Range

→ Perfect for contrasty scenes
→ Use a tripod and self-timer
→ Bracket exposure (-2EV, +/-0EV, +2EV)
→ Focus in Live View

Take Better Photographs in Difficult Situations

Midday?
→ Use a circular polarizer
→ Shoot at 90-degree angle to sun for bluest skies

Cloudy?
→ Look for waterfalls, wild-flowers, and forest scenes
→ Cut out the sky

Tricky Lighting?
→ Bracket your exposures!
→ Consider shooting in HDR

Rain?
→ Look for dramatic lighting, cool clouds, and water droplets on plants
→ Protect your gear!

Nighttime How-To's

Star Trails
→ Point at the North Star for circles, elsewhere for arcs
→ Use bulb setting and cable release
→ Low f-stop (< f/4.5)
→ ISO 100
→ Start with 30" exposure

Full Moon
→ Shoot moon near horizon
→ Use a telephoto lens
→ Use manual mode
→ f/11, ISO 100 at 1/125

Starpoints
→ High ISO (> 1600)
→ Low f-stop (< f/4.5)
→ Adjust shutter speed to achieve crisp starpoints

Composition Reminders

→ Use the Rule of Thirds
→ Balance the elements in the scene
→ 3 is better than 2
→ Simplify the scene
→ Fill the frame
→ Look for leading lines and S-curves
→ Change your viewpoint
→ Experiment with horizontal and vertical orientation
→ Pay attention to backgrounds
→ Be creative with colors
→ Look for symmetry, textures, and patterns
→ *Break the rules and have some fun!*

Create A Sense of Depth

→ Look for interest in the foreground, middleground, and background
→ Frame your subject
→ Take advantage of dramatic lighting
→ Change your perspective

Waterfalls

→ Avoid direct sunlight
→ Use a tripod
→ Slow your shutter speed to 1" and adjust to your liking
→ Use low ISO, high f-stop, and neutral density filter

Lake Reflections

→ Shoot early in the morning or just before sunset
→ Look for interesting foreground subjects
→ Use small aperture for deep DOF

Shooting Tips for Common Subjects

People

→ Vary the pose
→ Pay attention to the direction of the sun
→ Remove hats to avoid shadows on faces

Wildlife

→ Focus on the eye
→ Aim for catchlight
→ Shoot at dusk and dawn
→ Approach cautiously and quietly
→ Leave room to move
→ Include look space
→ Shoot at eye level

Flora

→ Overcast light is best
→ Use a shallow depth of field to blur the background
→ Clean the scene
→ Avoid hot spots
→ Background separation
→ Use fill flash

Action Shots

→ Use a fast shutter speed (≥ 1/250)
→ Use Continuous Shooting Drive Mode
→ Anticipate movement
→ Pre-focus
→ Use AI Servo to track subjects on the move

Scenics

→ Check your horizon line
→ Work your subject from all angles
→ Include people for scale

Sunrise & Sunset

→ Scout your location in advance
→ Arrive early and stay late for alpenglow
→ Bring your headlamp

Sunset Silhouettes

→ Start with mid-range depth of field (f/8 - f/16), fast shutter speed (> 1/125), and low ISO
→ Meter off the sky and recompose
→ Underexpose
→ Manual focus on your subject
→ Use exposure compensation to adjust

Nighttime Shots

→ Scout your location
→ Use a wide angle lens
→ Choose foreground subjects that make interesting silhouettes
→ Set up minimum 15 ft. away from foreground element
→ Manual focus while still light out
→ Bracket your exposures

www.PlanAndGoHiking.com

Links & References

Photography Websites

Digital Photography School: digital-photography-school.com

Tips and tutorials for camera owners of all levels

Photography Life: photographylife.com

Provides digital photography reviews, articles, tips, tutorials, and guides to photographers of all levels

Cambridge in Colour: cambridgeincolour.com

Includes digital camera tutorials and advice on digital photography tips and techniques

Photographer's Ephemeris: photoephemeris.com

Helps plan outdoor photography shoots in natural light and landscape scenes

Roamin' With Roman: roaminwithroman.com

Runs instructional small group photo tours and workshops, photo blog, and offers instructional e-books

Trey Ratcliff: stuckincustoms.com

Fine art photography and travel photography, free HDR tutorials, photography tips, camera reviews, and photo editing software reviews

Hiking Resources

Backpacker Magazine: backpacker.com

Source for backpacking gear reviews, outdoor skills information and advice, and destinations for backpacking, camping, and hiking

Outdoor Photographer Magazine: outdoorphotographer.com

Guide to nature, wildlife, travel, and adventure sports photography, featuring the work of renowned photographers

Trail Groove: trailgroove.com

Free online backpacking and hiking magazine, forum, and blog covering outdoor gear, destinations, tips, techniques, and photography

Outdoor Project: outdoorproject.com

Find hiking destinations, campsites, cabins, and parks; provides detailed trail maps and amazing photography

Blogs for Hiking Photography Enthusiasts

Take A Hike Photography: takeahikephotography.wordpress.com

A blog dedicated to exploring and documenting our natural world

Young Adventuress: youngadventuress.com

New Zealand-based international traveler and hiker who blogs about her experiences

Walking With Wired: walkingwithwired.com

Oregon-based thru-hiker who has completed the Triple Crown and blogs about her hiking adventures, sharing the journey, one thru-hike at a time

Bearfoot Theory: bearfoottheory.com

Salt Lake City-based adventure travel blogger and photo enthusiast, who offers information for everyday explorers looking to go to easily-accessible outdoor destinations and to hone their outdoor skills

Bike Hike Safari: bikehikesafari.com

Australian Brad McCartney documents his life as an adventure cyclist, hiker, photographer, and nature lover

Trail to Peak: trailtopeak.com

Drew Robinson's source for finding day hikes, backpacking trips, international adventure travel, and weekend microadventures, includes gear reviews, trip reports, and photos

Uncornered Market: uncorneredmarket.com

Travel blog by Daniel Noll and Audrey Scott, offers advice, stories, and photos to help others create adventure in travel and life

Inspiring Nature Photographers

Art Wolfe: artwolfe.com

Renowned photographer, features nature and cultural photography workshops, fine art prints, stock photos, and books, and hosts *Travels to the Edge* and *Tales by Light* on TV

John Shaw: johnshawphoto.com

Accomplished nature and landscape photographer, includes galleries, blog, e-books, and workshops

Rick Sammons: ricksammon.com

Canon Explorer of Light, features digital photography, photo workshops, and travel photography

Tim Fitzharris: timfitzharris.com

Associate editor and features writer for *Popular Photography & Imaging* magazine; author and photographer of 27 books on wilderness and wildlife photography

NANPA Field Practices

The North American Nature Photography Association (NANPA) is North America's premiere nature photography organization. Founded in 1994, it has developed a set of ethical field practices that encourages responsible photography in the wild. Hiking photographers should make every effort to know these guidelines and adhere to them while engaging in their craft. The NANPA Field Practices are as follows:

PRINCIPLES OF ETHICAL FIELD PRACTICES

NANPA believes that following these practices promotes the well-being of the location, subject, and photographer. Every place, plant, and animal, whether above or below water, is unique, and cumulative impacts occur over time. Therefore, one must always exercise good individual judgment. It is NANPA's belief that these principles will encourage all who participate in the enjoyment of nature to do so in a way that best promotes good stewardship of the resource.

ENVIRONMENTAL: KNOWLEDGE OF SUBJECT AND PLACE

Learn patterns of animal behavior so as not to interfere with animal life cycles. Do not distress wildlife or their habitat. Respect the routine needs of animals. Use appropriate lenses to photograph wild animals. If an animal shows stress, move back and use a longer lens. Acquaint yourself with the fragility of the ecosystem. Stay on trails that are intended to lessen impact.

SOCIAL: KNOWLEDGE OF RULES AND LAWS

When appropriate, inform managers or other authorities of your presence and purpose. Help minimize cumulative impacts and maintain safety. Learn the rules and laws of the location. If minimum distances exist for approaching wildlife, follow them. In the absence of management authority, use good judgment. Treat the wildlife, plants, and places as if you were their guest. Prepare yourself and your equipment for unexpected events. Avoid exposing yourself and others to preventable mishaps.

INDIVIDUAL: EXPERTISE AND RESPONSIBILITIES

Treat others courteously. Ask before joining others already shooting in an area. Tactfully inform others if you observe them in engaging in inappropriate or harmful behavior. Many people unknowingly endanger themselves and animals. Report inappropriate behavior to proper authorities. Don't argue with those who don't care, report them. Be a good role model, both as a photographer and a citizen. Educate others by your actions and enhance their understanding.

List of Abbreviations

CF	Compact Flash (Memory Card)
DNG	Digital Negative (File Format)
DOF	Depth of Field
DPI	Dots Per Inch (Resolution)
DSLR	Digital Single Lens Reflex (Camera)
ELI	Exposure Level Indicator
EV	Exposure Value
HDR	High Dynamic Range
HTML	HyperText Markup Language
IS	Image Stabilization
LCD	Liquid Crystal Display
LED	Light Emitting Diode
mm	Millimeter
NANPA	North American Nature Photography Association
NP	National Park
SD	Secure Digital (Memory Card)

About the Authors

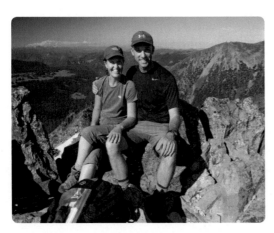

Matt and Alison met as undergraduates at Northwestern University in 1991. They discovered their enthusiasm for travel while living in Italy after college. As newlyweds, they developed a mutual love of nature photography and have since combined this passion with international travel and a variety of outdoor activities. From trekking in Nepal to safari in Africa, from backpacking in Patagonia to canoeing in the Boundary Waters, the camera has served as a constant reminder to pause and savor the subtle beauty of nature.

Alison and Matt began their backpacking lives in Chile with a thru-hike of the "W" in Patagonia's Torres del Paine National Park. Since then, their backpacking and trekking adventures have included Mount Fitz Roy in Argentina, the Annapurna Circuit in Nepal, the Inca Trail to Machu Picchu, the summits of Meru and Kilimanjaro in Tanzania, the Four-Pass Loop in Colorado, the Laugavegur Trail in Iceland, the Himalayas in northern India, the Wonderland Trail around Mount Rainier, and the Cordillera Blanca and Huayhuash ranges of Peru. In the summer of 2016, they completed the 210-mile John Muir Trail in the High Sierra of California, and they most recently returned from hiking New Zealand's Routeburn, Kepler, and Rakiura Tracks.

While not on the road, Matt and Alison reside in Chicago, IL. Matt teaches Latin, Greek, and Ancient History at a private high school, while Alison teaches technology at a K-8 public school. Matt and Alison document their traveling adventures and feature their photography on their blog, Take a Hike Photography: *http://www.takeahikephotography.wordpress.com.*

Plan & Go Guides

Researching the necessary information for your next self-guided adventure yourself is a time-consuming process and always carries a risk of missing important details. Consulting an expert or hiring a tour guide is costly and may limit your flexibility. Plan & Go Guides are the smart alternative to both of these options as they offer well-researched information paired with first-hand experience for a wide range of outdoor recreation activities.

Each guide features a particular expedition and provides essential detail to inspire and support outdoor enthusiasts in the process of carefully choosing and diligently planning their next self-guided tour. Clearly structured facts, practical insights, and step-by-step instructions will enable readers to be thoroughly prepared and to get going faster.

Learn more at *www.PlanAndGoHiking.com* and follow us on:

We look forward to and appreciate your feedback!

Disclaimer

The information provided in this book is accurate to the best of authors' and publisher's knowledge. However, there is no aspiration, guarantee, or claim to the correctness, completeness, and validity of any information given. Readers should be aware that internet addresses, phone numbers, mailing addresses, as well as prices, services, etc. were believed to be accurate at time of publication, but are subject to change without notice.

References are provided for informational purposes only. Neither authors nor the publisher have control over the content of websites, books, or other third party sources listed in this book and, consequently, do not accept responsibility for any content referred to herein. The mention of products, companies, organizations, or authorities in this book does not imply any affiliation with or endorsement by author(s) or publisher, and vice versa. All product and company names are trademarks™ or registered® trademarks of their respective holders.

This book is not a medical guidebook. The information and advice provided herein are merely intended as reference and explicitly not as a substitute for professional medical advice. Consult a physician to discuss whether or not your health and fitness level are appropriate for the physical activities describe in this book, especially, if you are aware of any pre-existing conditions or issues.

Made in the USA
Lexington, KY
28 November 2017